T0077979

PHILIP
AND THE
EYE GLASS

TCHANGO BORIS

authorHOUSE

AuthorHouse™ UK
1663 Liberty Drive
Bloomington, IN 47403 USA
www.authorhouse.co.uk
Phone: UK TFN: 0800 0148641 (Toll Free inside the UK)
UK Local: (02) 0369 56322 (+44 20 3695 6322 from outside the UK)

Published by AuthorHouse 10/08/2021

ISBN: 978-1-6655-8477-7 (sc)
ISBN: 978-1-6655-8476-0 (e)

Print information available on the last page.

Characters:

- Mr. August Johnson (father)
- Mrs. Jane Johnson (mother)
- Phillip Johnson (protagonist)
- Jessica Johnson (sister)
- Mrs. Parker (history teacher)
- Amber Ortega
- Devon
- Organ
- Austin
- Physics Teacher
- Math Teacher
- Yuan Chang

(This is a story about a young, sixteen years old Black boy living in LA who gets help in life by a scientific eye glass given to him by a Chinese person. So, how does the eye Glass help him out? The story takes place in a black family called the Johnson's. The family consists of a father, mother and their 2 kids).

INT. Johnson APARTMENT- BEDROOOM- MORNING
It was a beautiful morning during school section and Phillip was still asleep because of the late night movie he saw at night. Mr. August Johnson (Phillip's father} enters Philippe's bedroom who was still sleeping and yells in his ears.

Mr. August
hey boy! It's time for school!

Phillip jumps in his sleep and exclaims putting an annoying face.

Phillip
Dad!

August laughs and goes out of the bedroom. He shouts:

August
I give you only five minutes to get moving after which I will come upstairs and give you a bubby. I hope you haven't forgot how bubby works?

Phillip unwillingly wakes up and goes in the toilet to brush his teeth. Jane Johnson calls her daughter Jessica:

Jane
Jessica?

Jessica
Yes Mum?

Jane
What are you still doing inside? Do you want to get late for school?

Jessica walks out of a door and bumps into her mother. She apologizes, sits at the table and begins to sign her tea. Phillip comes down and greets his mother

INT. Johnson APARTMENT- Phillip in the living room- MORNING

Phillip
Good Morning mother.

Jane
Good morning Phillip. Tea?

Phillip
Sure.

Phillip sits at the table and is about to pick up his cup when August comes and drags him by the ear to their car:

INT. Johnson and Phillip are outside the house-

MORNING

August
Hey Phillip,this is going to be your first day at school, don't you know that?

Phillip
So?

August closes the door and sits inside his car

August
So? That means you were supposed to be inside the school before the others.

Phillip
But why?

August makes a confused face and keeps driving. They reached the school, Phillip gets out and is about to close the door when August holds him back:

August

Hey Phillip, I know that you are a new student but I don't want you to see yourself like that, you know what I am talking about huh? I want you to focus on your dreams, and build up your future with your own hands. Don't damn listen to what people say to you, you understand boy?

Phillip nods and goes inside. He looks around searching for his class but can't find it. He tried getting help from anybody but no one gave him attention rather they made fun of him. so there came a guy who saw how lost Phillip was and noticed him to be new in school, and he helped him to his when he asked Phillip of the class he was in. when they got there, he thanked the guy who helped him to his class and he enters with a slip from his pocket. Then a lady who is the teacher of that class welcomed him and she reads the slip:

Parker

Oh I see. You must be the new student Mr. William told me about yesterday. You are Phillip Johnson, right?

Phillip

Yes Ma'am.

Parker

I'm Miss Parker, your new history teacher. I hope you like this school. Hey Phillip, you know, you are the only black guy in the class right? But I want you to get one thing straight- You don't see yourself as the darkness right, I want you to be the light, do you get that? Don't pay heed to any insults anyone throws at you, okay?

Phillip
I understand ma'am.

Parker
Then what are you waiting for? Go join your class.

Phillip starts looking for a place. All the white students refuse to seat with him beside them. A notorious fellow puts out his leg to trip him. Phillip trips and falls to the ground. The class explodes into laughter except one girl called Amber Rose.

(Amber Rose is the 18 year old daughter of a rich white man in New York City called Mr. Thomas Ortega. No one knows this and are unaware of Amber's real surname- Ortega a Girl who always wear short skirt).

Ms. Parker angrily.

Parker
What's going on here? Who did this to Phillip? Nick? Chris or was it you Clark?

Amber
It was Organ ma'am!

Organ glares at Amber.

Parker:
You should be ashamed of yourself Organ! You deserve a punishment. Don't worry, it'll be easy. Let's begin by cutting three marks from your next exam and giving those to Phillip, shall we? And that isn't all, you'll have to write ' I will never hurt anyone again' 500 times and submit it to me tomorrow. You better do it or you lose 5 more marks young man, get it?

4

Organ
Yes ma'am. its understood.

Parker begins writing on the board. Amber pulls Phillip to the desk beside her and asks her to sit:

Amber
Have a seat Phillip. I am Amber.

She holds out her hand for him. Phillip sits and shakes her hand.

Phillip
Hi, I'm Phillip.

Amber
I know that Phillip.

Both chuckle quietly. Amber was a cheer dancer in school and she asked Phillip if he can come watch her on her practice day and Phillip accepted. The bell rang for lunch time and the class gets over and recess begins. Phillip takes his Lunch from the cafeteria. He sees Amber who calls him to sit beside her. He sits and they began getting to know themselves. Meanwhile, Organ had spotted them when he suddenly shows up with four of his friends and stood in front of the table:

Organ
Well well, what have we got here? Mr. Phillip along with his savior. A great man, who won 3 marks from a slave like me. But you know what man?

Amber comes between the two.

Amber
Know what huh?

Organ
Whoa! so you've got a girlfriend already black man ?
Organ's friends laugh.

Organ
So tell me 'Mrs.' Amber? Have you told your latest love that you're a bit older than he is or that before him you were dating…..

Before Organ could finish, Amber punches him in the face, busting his nose. She holds Phillip's hand and begins running with him. They get out of the school and Amber leads him to her car.

Phillip
Where are you taking me? What are we doing for god's sake?

Amber
Shut up and watch.
She drives them to a bar and they get out.

Phillip
What on earth is going on here? I don't even know you! Where are we?

Amber
Chill. I want you to meet my uncle…and have a little party with you.

Phillip
Party?
They went in the bar through Amber car while Phillip ask himself while Organ watching at them going

Phillip self
She has a Car? When they both reach there, they saw Amber's uncle (Devon).

Amber

Devon!

Devon pulls her away from Phillip:

Devon

What the hell are you doing here?

Amber

What do you mean?

Devon

I mean that you are supposed to be in your school right now and you are here in a bar, that too with a kid.

Amber

Kid? What kid?

Devon holds her by her neck and shows him Phillip:

Devon

That goddamn kid. Why did you bring him here? Don't you know I can get into trouble because of this? What if his dad comes to know that his son was here?

Amber

Hey stop freaking out. First see, he is not a kid and secondly, he's just a new student from high school. I mean, So why are you so worried? Chill!

Amber goes to Phillip and calls out to Devon:

Amber

Hey Deve! get us two bottles of juice not alcohol, okay?

Phillip

What were you guys talking about?

Amber
Hey you don't need to know that okay?

Phillip
Okay.
Devon brings them two glasses of juice, hands them over to the two of them and they begin drinking. Due to the loud music in the bar, Amber is forced to shout:

Amber
So Phillip! Is this your first time in a bar?

Phillip
I guess it is.

Amber
Great! Are you new to the city?

Phillip
Yeah.

Amber
Even better, that means I've got a lot of things to show you.

Phillip
Sounds nice!

On the other hand, Phillip's dad, Mr. August reaches the school to bring Phillip home. He reaches a bit late and the school had already dispersed. He starts looking for Phillip but cant find anyone. He is about to leave when Organ comes about and says.

Organ
If I'm not wrong, you are Phillip's dad?

August
Yes I am, do you know where Phillip is?

Organ
Sure!

(then said to him self into his mind that) I wonder why he looks like him (then, when he finished speaking to him self, he directly reply back to August) Oh, you should look for him at the 50th street century, I'm sure he will be there directly, August ask him back

August
What? Are you sure he went there? Who did he go with?

Organ
I don't think I am the right guy to tell you. But I assure you, that you will find him there.
August runs out of the school and calls back:

August
He better be there or you are in trouble boy.
He starts his car and drives to the bar. He steps in and begins looking for Phillip. Phillip notices his dad and his smile fades away. Amber notices and asks:

Amber
Is something wrong?

Phillip
Its my dad, he is here.

Amber turns around.

Amber
Your Dad?

Phillip
Yes. If he sees me here, he'll knock the daylight
outta me, I have to go now.

Amber
Okay, I'll drop you to your home, lets move.
*They get out of the bar and sit inside the car.
Phillip bends down to hide Himself. They start
moving but August comes out and sees them.*

Amber
Now, what was your dad doing here?

Phillip
I don't know… but please get me home before he does.

Amber
Don't worry, you don't know a driver like me.
*Amber stamps her foot on the accelerator and Phillip
shouts:*

Phillip
Nooooooo! I don't wanna die!

They reach his home and Phillip gets out.

Phillip
That was one fast ride. Where did you learn to drive
like that?

Amber
I'm afraid I can't tell. Its just a personal thing.

Phillip
Okay. Bye.

Amber
Nice meeting you. Goodbye.
Phillip goes inside his house. He sees his mom sitting in the living room with five of her friends. One of her friends sees him and tells Jane about it.

Jane Friends
Hey Jane, your son is back.

Jane
Is he?

Phillip
Yes mom.

He runs to his room and starts doing some work. Later, August reaches home and asks Jane if Phillip had come back.

August
Hey hon, is Phillip back?

Jane
Yes.
August runs upstairs and opens Phillip's door.

August
Hey boy, how was school today?

Phillip
Great!

August
You know, a strange thing happened today. When I came to pick you up, one of your friends told me that you were at the bar. I went there but you were lucky I didn't see you there, aren't you? Coz you know what I'd do to you right?

Phillip
Yes dad. You would make my brain eat my bubby.

August
Yeah but how did you know that?

Phillip
You always say that Dad.

August
Really? I didn't know that. okay see you in the living room.

Phillip
okay.

August goes out. Phillip breathes a sigh of relief. August goes downstairs and greets his wife and her friends. He takes the glass of juice Jane was having and finishes it for her. Jane asks her how was the day.

Jane
How was your day?

August
Pretty great.

Night falls, Jane bids her friends goodbye. Jessica runs to her mother and holds her legs. Jane picks her up lovingly and makes her sit at the dining table. Phillip comes down and sits beside Jessica. Jane gives them plates for dinner. August joins them as Jane brings bowls filled with food. They take their share and Jane serves Jessica. August makes a prayer:

August
Holy father bless this food and always keep us together for family is all we got. Amen.

They begin eating and Jane starts talking to her son:

Jane
So Phillip, how was your first day at your new school? Did you enjoy your company?

Phillip
Yeah. Quite Great. We did a lot of things today.

Jane
Lot of things like?

Phillip
like umm..history.

August
Interesting. That's it? Are you sure you were in school today?

Jane
I didn't get you August.
August pushes his plate aside and points at Phillip with his spoon:

August
I mean that your son wasn't at school today!

Jane stops eating, and asks Phillip

Jane
What is your dad talking about Phillip?

Phillip
I don't know mom, I was at school all day!

August

Oh so you mean to say that your father is a goddamn liar? Look at me Phillip, do I look like I am a liar?

Phillip

No dad, I didn't mean that. All I wanted to say is that maybe you are mistaken. You were the one who dropped me to school weren't you?

August:

That doesn't mean you attended school the whole day!

Jane

Come on August, calm down, I trust him, lets stop this conversation and finish our plates before the food gets cold.

Phillip gets up and pushes his plate aside:

Phillip

I am not hungry anymore, you can eat mine if you'd like to.
Phillip starts climbing the stairs leading to his room.

August

What! Come down Phillip right now boy!
August stands up but Jane pulls him down.

Jane

Let me talk to him okay?

August

okay hon.

Jane goes upstairs and enters Phillip's room.

Jane

You know, when your dad and I got married, we had to wait for fifteen long years before we had you. Your dad had a lot of problem as a teenager at school. He wasn't too great as a student and that's why we aren't as rich as other people. That's also why your dad has great expectations from you. He wants you to be a great man, not like him. So Phillip, if you are facing any problems at school, do share them with me.

Phillip

I will mom. But tell me what happened with you? Did you go to school? Don't get me wrong but asking you my doubts in physics and math is like asking a carpenter to do plumbing work!
Jane starts laughing.

Jane

Phillip, you are underestimating me! I went to school but I studied in Africa before coming here to pursue higher education. Your granny was in poor health and she wanted to see her grandson before she died. And I fulfilled her last wish by giving you birth.

Phillip

Mom, where in Africa?

Jane

Cameroon darling! Okay enough questions for today. Now come downstairs and finish you dinner, it must be frozen by now.

Phillip

okay.
Jane kisses him on the forehead and she leaves. Next day August drops Phillip to school but doesn't talk to him along the way. Phillip gets out of the car

and is about to go inside the school when August stops him

August
Hey boy, I know yesterday I wasn't a good dad. I should've trusted you and shouldn't have talked to you like that, so, I want to apologize. Do you forgive me?

Phillip
Of course dad, I did that yesterday.

August
Great! Have a good day.
They bump their fists in a strange way and make flying gestures with their hands and then Phillip goes to school. As he enters the classroom the bell rings and he sits beside Amber. Meanwhile Organ was jealous about them and was thinking of a way on how to get them.

Amber
So how was the night Phillip? Did your father catch a whiff about what we did yesterday?

Phillip
Well sort of. But he was surprised that all we did yesterday was history!

Amber
He's extremely mistaken if you ask me. hahahaha!
Back at home, Phillip's parents have a talk about the day before.

Jane
You know, Phillip is still a child and we are supposed to inculcate in him a good attitude that will help him to live joyously and happily.

August

I know. But you've got to understand that we are the ones who have to teach him that the world of today isn't the one which we lived in yesterday.

Jane

I guess you are correct. I hope Phillip grows into a brilliant man.
At school, the mathematics teacher enters the class and apologizes for
being late:

Math Teacher

Hey Class, sorry for being late, but I assure you that this wont happen again. Now where were we yesterday? Oh yeah Linear equations. Now I want the new boy, to solve these questions:

He writes the following questions on the board:
$6x-3x=2x-2$ $6(2x-5)=4x-8$

Phillip is unable to solve any of them and stands there dumbstruck and thinking about his
mother word of yesterday.

Organ

Well, who are we seeing here? Phillip the guy who came first in his class in 1998! hahahaha!

Amber

So what if he doesn't know anything? Are you sure that you know better than him?

Organ

Hey Phillip, please don't pretend that you know something because you will be disappointed if you fail but doomed if you don't try.

The class laughs at Phillip. He cant stand the humiliation and runs out of the classroom despite his teacher shouting behind him. Amber runs behind him too. She catches up and holds his hand.

Amber
Where do you think you are going?

Phillip
I have to go back home.

Amber
You can't go back right now! What will your father say?

Phillip
I don't care about that. I care about my future and I don't see my schooling helping that.

Amber
Listen you are disturb. You must understand that you have worked hard to reach here. I want you to come to my home and I will help you with the subjects in which you face difficulty. Will you come?

Phillip
I dont know. I'll try.

Amber
Here's my phone number. Call me when you wanna come and I'll pick you up.

Phillip
Thanks for your help.
Phillip leaves. Amber returns and finds that Phillip's books are missing.
The math's teacher wasn't in the class. She finds them with Organ who was laughing at Phillip's work.

Amber

Hey Organ, leave those books right now.

She charges towards him and pulls his shirt. It gets torn. She snatches the books from his hands and puts a pen dangerously close to his eyes.

Amber

Next time if I see you near his books, I swear that you will find this pen in your right eyeball.

So after school Amber had to attend her rehearsals as cheerleader. While she was rehearsing, she missed a step and the opponent cheerleaders laughed at her. Meanwhile as Phillip was heading home, he remembered that it was time for Ambers rehearsals so he went to see her. When Amber saw Phillip, she became more determined and did more extremely than anyone else in the hall. After the rehearsal, she hugged him and thanked him for being there for here even when I had no hope on improving. See you in my house then, said Amber to Phillip. Then they departed. Phillip is going home, it starts raining and he takes shelter at bus stop. He sees a Chinese man called Yuan Chang passing in front of him. He was drenched and was suffering from a terrible cold. Phillip took off his jacket and offered it to the man.

Phillip

Here Sir, you need this.

Yuan

No thank you.

Phillip

You must take it sir or you'll end up in the hospital.

Yuan
Seriously, I don't need it.

Phillip
Okay sir, if you don't agree, then I will no longer wear my jacket and you will be responsible for me going to the hospital.

Chang agrees to put on the jacket and asks Phillip to follow him. Phillip does and he leads him to his house. Phillip goes inside and marvels at the pictures hanging on the wall.

Phillip
I'm sorry sir but what was your name?

Yuang
I'm Yuan Chang, call me Chang.

Phillip
Nice to meet you Mr. Chang, I am Phillip Johnson, call me Phil.

Phillip
Sir, who are the people in these pictures?

Yuan
They are my family. They passed away in an accident on their way from Paris.

Phillip
I'm sorry to hear that.

YUAN
Its okay phil.
Phillip touches the pictures. When he touches a small one on the right, a door opens and he falls into it. The room was lit in red light and Phillip

was freaked out. Chang is surprised to see that Phil had vanished and understands that he went inside his burning room. He presses the same picture again and he comes inside the room. Phillip doesn't know that he is in there. Chang touches him on the shoulders.

Phillip
Aargh!! Oh man you scared me like hell.

Chang switches on the lights and Phillip looks around. He sees several computers and asks Mr. Chang:

Phillip
Don't get me wrong Mr. Chang, but are you a spy or something?

Yuan
I'm not a spy Son.

Chang goes to a computer and presses a button. A few seconds later, a voice speaks:

Computer
Welcome Mr. Chang, what can I do for you?

Yuan
Open the budget file please.

Computer
As you wish sir.
Chang begins working on his computer leaving Phillip to inspect the other items in the room. Phillip notices a beautiful eye glass on a table and picks it up. He wears it but fins that nothing was visible i.e. everything wasn't well with the glasses. The eye glass finally stitches on itself and speaks

Glass
Welcome to the base system of Chang technologies.
What is the user's name?

*Chang hears the glass' voice through his computer
and is alarmed. He gets up and snatches the
glass from Phillip's face.*

YUAN
What are you trying to do man?

Phillip
Nothing just seeing. What is this thing?

YUAN
It's an eye glass, it gives answers to all of your
questions just by asking the question in your brain.

Phillip
You're kidding right? I mean, can it answer anything?
Like, even math problems?

YUAN
Yes, it can, in seconds.

**Phillip directly became so surprise and excited to
bring it into his school and he quietly said to the
Chinese**

Phillip
Oh my God, Mr. Chang I need this thing right now.
Tell me, how much do you need for this? I'll talk
with my dad.

Chang
hey, this thing isn't for sale okay? I think you've
seen too much, you should go home now.

Phillip
But……

YUAN
No i don't want to hear anything, leave right now. *Chang pushes him out of the secret room and leaves him outside his home in the rain. Phillip runs back home. He goes straight to his room, changes his clothes and take a nap. In the evening August knocks on his door*

August
Hey Phillip, you awake boy?

Phillip wakes up and says:

Phillip
Yes dad, come in.

August
Hey, you've been sleeping the whole day, now come downstairs and have dinner, okay?

Phillip
Yes. I'm coming.

The family have dinner and they go to sleep. Next day August drops Phillip to school. Phillip enters his class and soon the physics teacher enters the class as well. He starts teaching, but Phillip and Amber don't pay attention and are busy talking and giggling. The teacher notices and comes towards them:

Physics teacher
Hey you two, what do you think you came here for, huh? Giggling ? I bet you didn't listen to a word that I just said, let's test you two. Tell me Ms. Amber, what is newton's third law?

Amber
Sir, it states that every action has an equal and opposite reaction.

Teacher:
Okay, now Phillip, what is the mathematical statement of Newtons second law? *Phillip stands silent.*

Organ
Sir, force equals mass times acceleration.

Teacher
Good, Organ. Shame on you Phillip.

Phillip is upset and recess begins. He sits down with Amber and begins having lunch when Organ comes to their table and shouts:

Organ
Everyone present here, I want you to listen to me for a few seconds. Please join me in celebrating the genius of Phillip Johnson!

The Class erupts in laughter.

Amber
Don't let him trouble you Phillip, he's just a mad lunatic that has a grudge against you, believe me that's all. Here, let me get some more juice for you.

Amber goes to the counter and in the meantime, Phillip runs away because he was ashamed of himself. Amber notices his absence

Amber
Hey Organ, where did Phillip go?

And Organ began to laugh at her with his friends by answering back directly after her question.

Organ
Am I Phillip gold keeper?

And immediately, all of them begin to laugh out loud.

Organ and his friends
Ha ha hahahah……

While Amber reply back to Organ.

Amber
I swear to god that, if something happens to him, you would end up in hospital by the end of the day.

And Organ finally said.

Organ
Oh….. Mrs. Amber rose… ha ha ha ha.

She charges out of the gates and finds Phillip crying under a tree. Phillip sees her and runs out of the school. Amber calls for him, but he doesn't stop. He starts running towards Chang's home as he feels that his Glass could help him. He finds his front door locked but fortunately the window was unlocked. He enters and touches the painting. The secret passage opens and he enters. He soon finds the Glass in some rucksacks. He puts the glass on and spoke in a tiny voice joining with his brain:

Phillip
Hello?

Glass
Welcome to the base system of Chang technologies. What is the user's name?

When the glasses answer him back, Phillip jump up by being amaze, then continue to reply back the same way, by using his brain through his mind

Phillip
Phillip Johnson.

Glass
Okay Mr Johnson, what would you like your password to be?

Phillip
Amber rose

Glass
Okay Mr. Johnson, I am all setup and now you can ask me anything.

Phillip
What is the mathematical expression for Newton's Second Law?

Glass
It states that force equals mass times acceleration or F=M x A.

Phillip
Cool!

He hears some noises coming from the gate and rushes out. Mr. Chang was home. He steps out of the window but Mr. Chang sees him fleeing and shouts after him:

Chang
Hey Phil! Stop!

Phillip keeps running until he gets far away from his house. He calls Amber at a payphone.

Phillip
Hello?

Amber:
Hey Phillip! My god! Where were you? I thought something happened to you.

Phillip
I'll tell you later. Listen can you come to the 50th street? I'm scared like hell, can you come?

Amber
Okay Phillip I'm coming. Don't move.

Phillip
Great. See ya.

Phillip waits for her. After 15 minutes, Amber reaches him and he sits beside her.

Phillip
Where are we going?

Amber
My house. Don't worry. Why were you so scared? Don't leave like that ever again without telling me, alright?

Phillip
Okay, I won't. I'll tell you everything later.
Amber drives to her home. Phillip is surprised to see the size of the building

Phillip
Is this your home?

Amber
Yeah, why?

Phillip
Um, because its quite huge, I mean I cant believe this.

Amber laughs and guides him in. They sit in the living room and a woman brings them water. Phillip notices a picture of Amber and her family:

Phillip
Hey, where does your family live, I mean I cant see them here?

Amber
Don't tell anyone about this. My dad is a rich businessman in New York but he makes me live here so I don't get spoilt by his wealth.

Phillip
I see, but strange.

They have food and later Amber drops Phillip at his home. He gets in through the window and goes to sleep. The next day Phillip wakes up early, wakes up his parents and greets them. He makes tea for them and cleans up the home. His parents are surprised but pleased. At School, Phillip wore his eye glass .Amber notices and asks him about it. He lies by saying that his doctor recommended it. The math teacher notices the two of them talking and asks Phillip a couple of questions.

Organ
Hey have a look at the genius Harry Potter!

The class starts laughing, but Phillip didn't mind. He asked his glass the questions and he was able to answer them all.

Phillip
Now Organ, can you solve this equation for x, $7x-4=5x-2$?

Immediately, Amber was so surprise at his question and hold him on his dress by asking him this.

Amber
Hey! What are you doing?

Phillip
Watch and see.

Then, turn back, and look at Organ and ask him back. (So???????)

Organ
Ah, ummm…… we haven't reach at that level yet

Amber
Oh oh oh; Now who is the genius Organ? Ha ha ha ha

And directly, The class begin to laughs at Organ for the first time. The period gets over and physics begins.

Physics teacher
Okay class, today I'll be taking a test.

Then look at Phillip wearing his glasses and she was so shock and she immediately said to Phillip by putting her own glasses down from her eyes and looking at Phillip face to face. (oooh ooh ooh ouh ooh…; what are my seeing here?). While al the students was saying…

Class in unison
Oh no……..

And she directly reply back to the class after hearing them crying about the test

Physics teacher
Oh yes! here are the papers and your time begins now.

Then Organ turn and look at Phillip by saying

Organ
Hey Phillip, let's see how you get away with this one.

Phillip faces difficulty in choosing whether to use the glasses for the test or not. He sees the happy faces of his parents when he would show them his great marks. He also sees their angry faces when they would come to know that he had cheated. Still, he decides to use the glasses. At the end of the day, they get their papers back and Phillip got perfect marks. Amber was surprised and asked him how did he pull that off.

Amber
Hey Phillip, how did you do all that?

Phillip
Well, it wasn't me who did that.

Amber
Then who?

Phillip
It was my glasses.

Amber
Really? How is that possible?

Phillip narrates to her how he met Mr. Chang and how he stole the glasses from his home. Amber asks him to come to her house so that she could try those glasses and Phillip agrees. Then, after that, Phillip saw him self with Organ, Organ friends and some others students boys, playing hand ball, so,

Phillip who was playing with friends, directly, Organ and his friends was refusing passing him the ball, and Phillip was getting angry, by asking them.

Phillip
But why are you guys not passing me the ball too?

Then Organ smile and he said to Phillip.

Organ
Aw, you need the ball? Okay, Wait, when the right time will come I'll pass it to you.

Then, their sport teacher use his hands for the game to start back, and the continue playing, until, Organ shouted to Phillip by saying. (Phillip, here is it)

Then, empts the ball on Phillip face, and Phillip felt down, then the sport teacher stop the game, and ran over Phillip with Austin, and carry him up, then, the sport teacher remove him from the match for him to rest a while, and Austin told Phillip,

Austin
Don't mind them

Then, left Phillip on a chair, and ran back to play with the others who was already continue playing After some 2 hours, Phillip went into the kitchen holding his black bag on his hand by going where is mother was doing cake to ask her the permission to go out and study with his friend, and this is how the dialogue was going through

Phillip Johnson
Hey mom! Please is it possible if I should ask you something? Then his mother stops turning flour by looking at him directly by answering

Jane Johnson

Ask me anything you want babe.

Phillip Johnson

Are you sure mom? Hope you wouldn't be getting angry about my question?

His mother continue turning the flour and said.

Jane Johnson

Phillip, if you seriously want to eat something this night, then you have to stop questioning me, cause I hate questions a lot when I'm cooking, So…..

Phillip ask her this question very fast.

Phillip Johnson

Mom, is it possible if you should give me the permission to go out?

Then his mother turn back and look at him by answering fast too.

Jane Johnson

What the hell are you talking about? Going out where? Or have you forgotten your dad hate those types of things a lot? Your suppose to help me right here or been on your book study for tomorrow and you're here asking me the permission to go out just like that? Phillip!!!

Then Phillip directly reply.

Phillip Johnson

Mom, I'm not going out to play or do something your now having inside your brain, I'm going out just to study with a friend.

And his mother began to look at him strangely and reply back.

Jane Johnson
Ummhmm...; Are you serious? Cause I don't think so.

Phillip Johnson
think what mom? I'm serious, and if you want too, I'll be bringing you proof about what I did there, so what you think my little mother in Love???

With a great smile on Phillip face holding his mother on her kidney by keep saying 'mom please', she finally agreed with a smile too, and said to him.

Jane Johnson
Okay son, as you wish

He began to jump over the kitchen by singing and saying.

Phillip Johnson
Hey!!!! Mom mum mm mum, I love my you mummy, I love you more than everything, I love you and I love you mother, oh oh oh oh, you're the sweetest and lovely person I have never seen inmy whole life.....

His mother asked him to stop singing and she said to him.

Jane Johnson
Wait, wait wait…….. I have agreed just for you to take this advantage by running away from your dad, for him to punished you when you'll be back.

Phillip stop singing and turn back by looking at his mother and saying.

Phillip Johnson

Mom, what exactly are you talking about? Cause I can get you.

Then his mother reply by pointing the ladle that she was using to turn cake and answering.

Jane Johnson

What exactly I'm trying to say is that, you don't have to go there and come back late, cause if that happen, your dad will kill us.

So after listening to his mother messages, he directly run out by shouting and going and saying to her.

Phillip Johnson

Okay mom, I got you, I promise you I wouldn't be late, love you.

And his mother shouted aloud by saying.

Jane Johnson

Okay boy, hope you wouldn't fail your mother.

That same moment, blood came out from her nose and felt on the table, and she saw it and immediately wipe it on the table, So When Phillip reach outside from the house, that was the time Phillip dad August Johnson reach in front of the house watching Phillip running by going, and he shouted by asking Phillip.

August Johnson

Where the hell are you going to?

And Phillip who kept on running run while answering his dad question.

Phillip Johnson
I have ask mom the permission to where I'm going, so ask her yourself dad.

Amber Ortega driver was next to Phillip and he upon up the car by saying to Phillip.

Driver
Sir, Mrs. Amber sent this car for you.

And Phillip look at the beauty of the car strangely and said.

Phillip Johnson
Oh mama! Damn.

Then went inside the car, and the driver close up the car, and went inside too, and started driving, still Phillip reach there, and the same driver went and upon up that same door for Philip to go out, so when Phillip came out, he began to work towards the door by looking at the house strangely and with a great surprise, directly, Amber who was sitting a thread of her house saw him and shouted towards him that.

Amber Ortega
Oh oh, Phillip.

Then Phillip turn and look up and when he saw her, he began to smile more and he said.

Phillip Johnson
Hey!!!

And answer him back.

Amber Ortega

Hey Hey Hey! What are you still doing down there?
Hurry up, come in.

*Then he went and upon up the door of the house,
then he went inside the house, and began to go
up and going up until he until he arrived at the
show(living room) then she use her hand by touching
the chair she was on it by saying to Phillip.*

Amber Ortega

Come and sit right here on my side Phillip, come
on, don't be to scared, I'm a human being like you,
come on Phillip, come on.

*(Then Phillip began to come and sit where she was
with a few scared, then when he was sitting next
to her, she put her hands on his shoulders and she
look at him and ask him)*
Hey! Why did you bring up your back right here?

*Then he began to speak up to her slowly as if he
was scared, and he was saying.*

Phillip Johnson

Well, as you can see, if I wasn't bringing up my
back, my mother will not let me come here, that's
why I did so.

Then Amber stood up from the chair and she ask him.

Amber Ortega

Ummmmhmm; so tell me, what should I offer you for
drink?

Phillip wasn't scared any more because she wasn't
holding him on his shoulders again, and he answer
with a great smile.

Phillip Johnson
Anything you have.

Amber began to go into the kitchen and by saying.

Amber Ortega
Anything I have like, Soda, Pina colada, Red Bull, Cendol???

Phillip answer her back.

Phillip Johnson
Even if you have Sujeonggwa, Mojito, Cider, Yerba Mate, Mango lassi, Yakult and so fun and so on, just bring it to me.

And Amber answer him back with a great surprise by going to take it for him.

Amber Ortega
Hey! How did you know all those Drinks from?

Phillip Johnson
So simple, I have learn it from films, TV News.

Amber
Well well well, means when I'll be right back you'll tell me more, cause you have just name my favorite drink Pina colada, hummm, that one is delicious.

So when she came beside him with a big cup of juice who was Martini juice, Phillip look at it and ask her.

Phillip Johnson
Hey! What is it?

And she reply by sitting next to him.

Amber Ortega
Awww… don't tell me you haven't eat this one since you was born?

Phillip Johnson
yep! Who knows.

Amber Ortega
Okay, this is Martini, try to drink it and let us see.

Then Phillip decided to try and drink up the juice when suddenly he sound the juice very nice and began to make some noise with his mouth like.

Phillip Johnson
Hum, very delicious, perfect, You Could try bastardizing this sacred cocktail with various pollutants - Appletinis ? Chocolate martinis ?

Amber Johnson
Please stop! But nothing is ever going to change the magic That gin, vermouth and olives to do a long day.

Phillip Johnson
oh, okay, I see.
Then Amber took up Phillip bag from the chair, and ask him.

Amber Ortega
So tell me, where have you put up those glasses?

And Phillip directly put down his cup and remove those glasses inside his bag and said to her.

Phillip Johnson
Here it is.

By pointing those glasses in front of her eyes, then she hold it and she ask him.

Amber Johnson
So as you was saying to me early before coming right here, this glasses I'm holding, was made up by a great science Doctor?

Phillip Johnson
Yep! I can say yes, and I can still say no.

Amber Ortega
Yes and no how? What you mean by that?

Phillip Johnson
Meaning, the man who made up this eye glasses isn't looks like a doctor.

Amber Ortega
I don't get it.

Phillip Johnson
Okay! This eye glasses wasn't made by any doctor.

Amber Ortega began to look up to him very strangely and ask him back again.

Amber Ortega
What exactly are you trying to make me know?

Phillip Johnson
What I'm trying to make you know is that, I Stole them.
Amber shout over to him and said.

Amber Ortega
What? You stole them just like that? To who and for what?

Phillip Johnson
Please come down, come down, I'm going to explain to you everything, come down please.

By holding her hand and she close her mouth off and she reply.

Amber Ortega
Okay, I'm listen.

Phillip Johnson
As you can see, this glasses was made by a Chinese name Mr. Yuan Chang, and through the Technology of this Glasses, he helps me to develop my mental abilityand that's why I was having all this good marks in school.

Suddenly, Amber began to look at Philip strangely again after some few minutes, before she jump up from her chair and began to laugh and said.

Amber Ortega
(*laughing out loud*) Ha ha ha haahaha….. No way! What are you trying to do?

Then Phillip look at her and reply.

Phillip Johnson
What? Trying to do how? I don't get you.

Then she stood up from her chair, then began to work round the living room and by asking to Phillip.

Amber Ortega
What I'm trying to do or to explain to you its very simple, (*by pointing her fingers toward Phillip and continue saying*), you mean, this glasses are like magic?

Phillip who haven't understand her question ask her back.

Phillip Johnson
Magic how?

By taking the glasses to Phillip and explaining her question.

Amber Ortega
You said this glasses was made by a Chinese, and you also said that this glasses can help you out be more clever in school than before? (*while Phillip was saying yep to all her question she finally ask*). So how does it work? Does he have any magic word to spell before the glasses began to put all those answers inside your brain?

Then Phillip stood up by coming near her and then he took up that glasses from her, by showing her the method of the glasses how its work, by saying.

Phillip Johnson
Nope! Not that way your saying, first of all, this glasses isn't like harry potter eye glasses, but this glasses its more better than that, let me give you and example.

By posting on Amber face and continue saying.

(When you where this glasses, its helps you to have all the answers asking by Mrs. Paola, Mr. Williams, or any one you want).

Then Amber ask him with a strange a funny face.

Amber Ortega
How?

Then Phillip remove immediately the glasses on her face by saying.

Phillip Johnson
How? How? Don't you see anything written on it as a image or video?

And when he was holding the glasses by finishing his question while she was saying No, he directly posting on his face by asking her back.

(No How? Wait!).

Then when he put up the glasses, he find out there wasn't any video and he look at her and Amber began to smile at him and she said. Amber Ortega What a handsome boy. Phillip smile back at her and answer

Phillip Johnson
Oh! Thank you.

Then he directly remove back the glasses and ask back to him in a silence way a question. (But what is going on???) After thinking for 10 second while Amber was looking at him, he said to her. (Oh, well well well, now on I remember, as you can see, this glasses has a code). And Amber ask him by shaking her hands.

Amber Ortega
A code? I knew it Phillip, I knew it, I first told you that this glasses its like a magic eye glasses that use some magic words like, Shallababa, or schuldune, and you haven't listen to me.

While Phillip was laughing at her magic word she was spelling, he directly said to her.

Phillip Johnson

No, no no no, it doesn't use anything like that, simple, put back the glasses and you do exactly what I will told you to do.

Amber Ortega

Okay!

Then after putting it on her face, he said to her.

Phillip Johnson

Okay, now on that you have it on your face, try to think by asking to your self the more difficult question you have never ask it in your whole generation.

Amber Ortega

Okay!

Then she close up her eyes deeply during 15 second, then after, she ask to her self through her brain (mentality) some few questions who was.

(Who's the late grand parents of the Queen Elizabeth?). The Glasses came on, and after she saw a letter from it writing.

Glass

Welcome to the base system of Chang technologies. What is the user name?

Directly, she remove it back from her eyes and she shouted toward Phillip.

Amber Johnson

Hey! It's works, its works dude.

Then Phillip smile at her and said.

Phillip Johnson
A ha! I told you before, and you didn't listen, now as you can see, I wasn't lying to you, I wasn't.

Then Amber hold his hand close to her by asking him.

Amber Johnson
Please Phillip, tell me what's the next step? Cause the glasses have just ask me the user name, and I want to get inside of it more and more like you babe, please.

Then she kiss him on his cheek, and then its implementation has blush, and Phillip said.

Phillip Johnson
Awwwww…

Then right after he blush, Phillip said to her.
(Okay! The user name of the glasses its my name) And she reply back to him.

Amber Ortega
You mean, your name?

And he answer.

Phillip Johnson
Yes, I'm talking about my name.

Then she put back the glasses on her face and she ask him.

Amber
You mean Phillip Johnson?

Phillip Johnson
Yep! But remember, you have to use this glasses the same way I have teached you earlier.

Amber Ortega
Oh yeah, I know, through my brain.

And Phillip point his finger by jumping with one legs and answer her back.

Phillip Johnson
Oh yeah! That's it!

Then she began to reply to the question of the glasses by using her mentality.

Amber
Phillip Johnson.

Glass
What is your password?

Then she ask back to Phillip.

Amber
What's the password Phillip?

Phillip
Your name .

Amber blushes.

Amber
Amber Ortega.

The glasses refuse to upon the password and said.

Glass
Wrong password, try again.

Amber Ortega
No! Amber Rose.

Glass
Wrong password.

And she began to repeat it and repeat it (while Phillip was manipulating Amber phone) until the glasses went off, then she remove it from her eyes and she look at Phillip and she said.

Amber Ortega
Phillip, this shit doesn't work, what wrong with it?

Then Phillip who was standing near her window, turn back, look at her and began to come toward her by taking the glasses to her and by still asking.

Phillip Johnson
What are you trying to say?

Then she gave him the glasses by saying to him.

Amber Ortega
Take it yourself and see.

Then Phillip took it and he put it on his eyes then he ask to himself(brain).

Phillip
At which battle did Hitler die?

Glass
Welcome Phillip Johnson, what's your password.

Phillip
Amber Rose.

Directly the eye glass open up, and Phillip remove it from his eyes and then show it to Amber, she look at it and she began to smile, then Phillip gave her

to wear it on her face, and when she did that, the eye glasses ask her to said one question from her brain too, and she ask this.

Amber
Umm.. How many inches in a foot?

Glass
Twelve inches in a foot.

Amber
This thing rocks man!

After playing with the glass for a few more minutes, she takes them off. She comes close to Phillip and they kiss. They are interrupted by Phillip's phone. It was Phillip's mom who was worried about him.

Phillip
I have to leave Amber.

Amber
So soon?

Phillip
Yes, but I'll be back soon, can you drop me?

Amber
Sure.

While Going out from the house, Phillip saw a paper of a test book Amber was working on, and he stop working by asking Amber.

Phillip
Hey! Can I have it in my house and bring it back to you tomorrow?

And she look at him strangely for 5 seconds, before directly reply.

Amber
Ummm… Why not?

So they ran outside from the house, went inside the car, and Amber drive it by bringing him to the house, so after some 30 minutes, when they finally reach in front of Phillip door, Phillip upon up the car, and directly when he was going, Amber stop him back by saying.

Amber
Hey!

He turn back and look after her and she smile and said to hi. (Phillip, please don't mess up with my book, hope you wouldn't work on it?). Phillip smile and answer.

Phillip
Why should I? I promise you I'll take good care of it, and tomorrow, I'll let you know what I've done with the book, promise you Amber, Promise.

By saying to her "I promise you, he was going inside the house while Amber was going to her house, so when he reach in front of his door house who was already 7:32pm, directly, his mother upon up the door and came out, and when Phillip met her he smile at her, and she make a fake smile face for one second, before turning her face back as and angry face, so she went back home, while Phillip decided to go inside the house too with fear. Phillip comes home and Jane asks him

Jane
Where were you Phillip? I was so worried.

Phillip
Oh leave that, I've got something to show you.

He shows them his test paper and the family was delighted.

Jane
I knew you had it in you Phillip, you are going be a great man!

Phillip
Thanks mom!

Phillip has dinner and goes to sleep. Next morning at school, he is surprised to see Organ coming towards him.

Organ
Phillip, I am sorry about what all you had to face till date. I would like to apologize and would become your friend if you help me out in today's exam. What do you think?

Phillip
Oh really? But like you always say, you may be disappointed if you fail but you are doomed if you don't try.

Exams begin and Phillip doesn't show any answer to Organ, but shows them to Amber and the both was ending the examination 1st before the others, and all their classmate was very surprise watching them finishing it firstly and going out with a great smile on their face the way the examination was so easier. After the ending of their examination, Phillip stood up in front of the classroom, then began to shout to everyone by saying.

Phillip
Hey!!!

Then all the classmate turn around and look at him, while Amber was standing on her own side watching at Phillip speaking and Phillip was saying to them. (So guys, today is was the day we end up our first part of Examination, so what do you all think if we should go out this night and celebrate it before the result?) Amber who listen up to him saying that, came to his side and ask him with a smallest voice, so that others shouldn't listen to her asking that question to Phillip.

Amber
What! But What are you trying to do?

Phillip
Nothing much than trying to build up a celebration.

Amber
Celebration? What for? Are you sure in the day of the result, you'll past your exam?

Phillip
Why shouldn't past my exam? Are you scared?

She smile and reply back to him.

Amber
Scared? No! why should I be scared?

And while the was chatting, they others students was speaking louder, and Phillip shout back and ask them to stop speaking, so when they was a biggest silence, Phillip directly said.

Phillip

Okay, lady's and gentlemen, as you can see, we are not robot, we are human beings like others, who doesn't only have to study with out having any fun, so what do you think if we should all gather in one place and celebrate this?

Then, a young short and Chinese Australia girl name Angel ask him.

Angel

Celebrate it? But where are we going to do that, and as you can see, my parents will never allow me to go out specially in the night.

Then another student said.

Student

Even me, my parents will never give me that permission.

While they students was discussing, Organ who was hiding with his friends behind the door listen to them, Phillip who saw one of Organ legs(shoes) beside the door of the school directly stop the students by shouting over to them and he said.

Phillip

Hey! Guys, listen to me please, listen to me.

Then use his fingers by asking them to come near him and he said. (Make A Circle please). Then when they did that, he came in the middle and he said to them slowly, for Organ and his friends to not listen to what he will be telling them, so after saying that secret to the students, he end up by telling them louder. (So As you can see Lady's and gentlemen, Let's meet this night at 9 pm in Amber house, is

that okay?). And all they students said "Yeah!!!!and Austin put his hand up and shout and said.

Austin
I'll be the DJ.

After saying that, all the others students look at him strangely, even Amber, while Phillip smile at him and replying back.

Phillip
Good!

Then Organ and his friends ran away from that place by going, while the student's was going out form the school too. So when Amber and Organ left classroom, they both began to go out, and when Phillip and Amber Reach outside the school, they began to work and Amber Said to Phillip.

Amber
Tell me Phillip, are you sure our plan Going to work?

Phillip smile at her and reply.

Phillip
Why not!

Then turn back, and look at Amber by holding her on her cheek, and said to her.

Phillip
Understand something Amber, you're the only person that I trust in my whole life, even that I haven't be with you for long, so what exactly I want you to know is that, no matter what I may say to you, just believe in me, the same thing I'll do fore you.

Then she smile at him and they both kiss up, and then he hold her on the hand and they began to go, while they was working, suddenly, Amber had in mind that it was good for her to bring Phillip into the shop for her to buy him some clothes, So she stop working up and turn back and ask Phillip.

Amber
Tell me Phillip, what will you be wearing in the afternoon?

Phillip became surprise and ask her back.

Phillip
Huh? What should I be wearing how? What? Of course, my same clothes.

And she began to smile back again and began to bring him into her car by holding his hand and running with him and saying

Amber
No no no no no no. That will be impossible, cause I'm going to bring you in the most amazing shop you have ever been before.

Then they both went inside her car, while Phillip said.

Phillip
What? No way, please stop that.

And she turn on the car and she began to drive the car fast and that makes Phillip to be scared and he shouted over the street when the car was going like.

Phillip
Nooooooooooo

And she was there laughing at him, while continue diving fast, and Phillip was keeping saying to her. (Noooo….; Amber……Stop….). And she was still laughing out loud, and people who was also driving their cars was surprise watching a young woman inside the car and driving fast, and some was insulting them by showing their head out side of their cars and by showing their fingers the sing of 'Fuck you' and also spelling the same word to them, until Amber reach in front of the dresses shop, and then she went out from the car sexiest by shaking her long hair and showing her sexy body with abs on it(stomach), and all the public who was working(passing) on their way started turning by looking after her, and some were even fallen, until when Phillip came out from the car, he fall down and those who was watching at Amber stop looking at her, and Amber who notice Phillip fall down, she immediately turn back and look at him and ran toward him, and when she was near him, she began to carry him up.

Amber
Oh my Gosh, are you okay?

And he reply by standing up through her help.

Phillip
Yeah! I am, of course I am.

Then she left him, and they both began to go inside the shop and when they reach inside, they saw a lot of people(youths, old, women's, men's, boys, girls even baby's) there who was buying some of their clothes, so when the look at those people, Amber turn round on her left, and she saw some lovely and beautiful clothes, like t-shirt, trousers, that Phillip can wear it up, so she began to go over there by saying to him.

Amber

Follow me!

Then Phillip began to run to behind her, so when they both reach where those dresses was, she began to pick some clothes and after some seconds, she stop picking it up and began to think and then continue picking it, so After picking many of those clothes, she then gave to Phillip and ask him to go inside the place where people love to change their clothes and Phillip went there, so when Phillip was inside there, he finally began to change his dresses and by coming out from that place and showing his sexy body, and they girl was very surprise to look at him sexy with a lot of abs on his stomach, and she was like 'Aw' and Phillip was she began to show her fingers to some clothes as a sign of good, and also taking him some selfie and also joining Phillip and making some Photo shoot with him, and sending it inside her social media pages, so when Phillip was continue changing clothes until he finished doing it, then she took some best clothes she has choosing for him and then Phillip put back his 1st clothes he enter inside that dress shop, so Amber took him near where they are giving credit cards for the person who's controlling that place to remove the amount of the money they both has spend by taking the clothes through the credit card, so when it was done, she took back the clothes and went out from that place with Phillip, while they both was getting inside the car, Phillip directly saw Mr. Yuan Chang coming inside that same shop to buy, then he hide him self behind Amber, and Amber saw it as a strange thing and she ask him.

Amber

What?

Then Phillip reply scared and trembling.

Phillip
Please, let's get out from here very fast before I'll
tell you what the problem, please.

And she immediately reply.

Amber
Okay, okay okay, as you wish Sir.

*By laughing out loud and going inside the car, and
when they reach inside the car, Phillip get in
fast, and Mr. Yuan who was inside the shop already
but still beside the door of the shop saw Phillip
inside of Amber car through the window of the
shop, directly began to ran outside from the shop
by coming near Amber car, while it was already to
late and Amber was already going with Phillip, so,
when they both was still going and that they were
already far from the shop.*

Phillip
Thank God.

Then Amber ask him.

Amber
So can you tell me now, why was you so scared
this way?

And Phillip reply by showing her the glasses.

Phillip
As you can see, I've met the owner of the glasses
coming inside the same shop we were in.

Amber
No way, your not serious?

Phillip
Yes way, I am.

Amber
So what should you be doing if the man finally caught you?

Phillip
I should be crying and asking God help.

And Amber began to laugh while Phillip ask her. (What's funny?) Then, they both continue going and going until, she brought Phillip inside her house, so when they both reach there, Phillip and her went out from the car, while the gate man was closing up the gate of her house, then she hold Phillip hand and they both ran into the house, so when they was finally inside the house, Amber maid began to work beside her by going inside the kitchen, Directly, Amber stop her going by saying.

Amber
Hey hun!

And she turn back, look at her and reply

Maid
Yes ma'am

Amber
Please is it possible if you can do me a favor?

Maid
Anything you wish to. I will ma'am.

Amber began to smile and she talking to her, while Phillip went and jump over the chair and on the television and began to watch at it.

Amber
As you can see, I have some classmate who will be coming here for party, so as for that, please I will seriously want you to do us some seriously food or cake, just think in anything you'll be doing, and if you need my help in anything, then I'll be here to help you out.

After making her last smile, her maid finally said.

Maid
Yes ma'am.

Then, Amber went and sit near Phillip and she took back the remote of the television and she ask him by smiling.

Amber
What are you looking at?

And Phillip reply.

Phillip
The last part of Spider man.

And she said with a great surprise.

Amber
Oh... Really!

Phillip
Yep!

When they both was watching, her maid came with
some pop corn and gave it to Amber for her to eat
it, with Phillip, while going back to the kitchen,
Amber said to her.

Amber
Thanks.

Then when they both began to eat it by smiling, the
next part of Organ he was there with his friends
speaking on how they will do to bring police into
Amber house and Organ was saying to his friends.

Organ
Guys, I think the best thing for us to do is to
wait until everyone is inside Amber house before
calling the FBI.

Chris
Why not the CIA?

Organ look at him with a dangerous face and said
to him.

Organ
How come the CIA? Do you know what your talking
about? So stop telling me shit.

Chris
Okay!

Then his others friends like nick, Clark look at him
strangely too. On the other side of Phillip family
Jane who was watching the television and drinking
her tea, directly, her daughter Jessica who wake up
from her bed came to her and shouting all over the
house and saying….

Jessica

Mom, mom mum mom….

Until Mrs. Jane turn back and look at her and reply by carry her on her lap and kiss her up at the same time she was saying to her daughter…

Jane

Oh! You wake up? What's wrong Babe?

Jessica with a hungry face reply.

Jessica

I'm hungry mommy.

When Jane listen to her saying she's hungry, she then said…

Jane

Oh! I didn't knew you'll be hungry this way, So should I make you some cup of tea?
Jessica reply back with a hungry face.

Jessica

Not only tea mom, with bread too.

Then her mother who put her back on the chair went inside the kitchen to make her a cup of tea, while the father of Jessica Mr. August Johnson was coming inside the house, so when he met his daughter inside the living room he came near to her and kiss her on her cheek then ask her.

August

Are you alright?

And she smile a bit and said.

Jessica
Yes Dad.

Then he ask back.

August
So where is mom?

And she point toward the kitchen by showing where his mother was, then his father kiss her back on her cheek by saying. (Good girl). Then he left her by going, so when he went until he reach inside the kitchen, he saw his wife drinking water and he kiss her up on the lips, then he ask her. (How are you?).

Jane
I'm good babe.

And he hugged her on the back, then say to her.

August
How did you spend your day?

With a great smile on their faces kisses both she answer back.

Jane
How do you want that I should spend my day when your not on my side, that will be impossible.

Then he husband laugh more on her and then he ask her.

August
Besides, where is Phillip?

Then his wife reply back to a strange way.

Jane

He hasn't come back.

Then her husband stop hugging her and began to be angry and he shouted.

August

What? How come he hasn't come back since from school while school end up early today?

By looking at his clock who was on his hand, he continue saying by showing the time to his wife (Look, it's already 3pm, are you sure he hasn't went any place else?). And his wife who finish looking at the husband clock answer back to him.

Jane

Not sure, but if he really went to his friend house, maybe, he went there for studying.

His husband began to laugh at her by saying.

August

Ha ha, your not serious, I know Phillip, today was the last day they was doing their exams, and I'm sure he went out with some friends to have fun.

Jane began to go out from the kitchen with Jessica cup of tea and a bread from her hand by saying to him, while he was following her behind....

Jane

No way! I know my son more than you, and as a proof, you know yourself that, since Phillip put up his legs into that racism school, people didn't love him a lot, specially because he was black and wasn't intelligent.

August went in front of her and said while she was putting up Jessica cup of tea on the table and call her to come and drink and eat by saying. (Jessie! come and drink your own tea). While saying that by going inside her room with her husband, the husband was also telling to her.

August

But have you forgotten that people change? And have you forgotten that since a week now Phillip is becoming more brilliant and intelligent?

Jane laughing and replying back to him.

Jane

Ha ha ha ha. Stop dreaming boo, since we have been in New York or Atlanta, Phillip has never bring us an A grade into this house, so why should it be now?

And her husband answer back while she was sitting on her bed and him changing his clothes.

August

Oh oh oh, your kidding me? Have you forgotten the exercise book he just brought to us yesterday?

Jane smiling at him and replying back.

Jane

Ummm... Babe, you doesn't know who your dealing with, I know Phillip, even if he has show us that, I'm sure, he hasn't done that himself, and when he will be back, then I'll prove to you A + B that he wasn't himself who did that exercise, trust me.

Then her husband finished up dressing, then she ask him. (Should I give you food or a cup of tea?)

August

Tea firstly before food.

Then, they both stood up and began to go out from the room, while in the other side of Phillip and Amber, their friends began to come inside the house by dancing all over and some was laughing and kissing up Amber and Amber was bringing them inside the Game room a place where there is tv ping pong, etc..., while they boys was greeting Phillip (who wasn't having his glasses on his face anymore but inside the pocket of his t-shirt) hand to hands on the gang star, by reaching inside Amber house, they all began to smile and they party begin, the dance, sing, smile and they did a lot of party, but the majority of those boys like Phillip and some like William, Austin, Teddy etc...., so when they majority of boys was playing each others, then Amber came near to them and she smile at them; then when Phillip turn back and look at her smile, and said to her.

Phillip

But why are you standing there? Come on, join us.

And she came toward them by laughing, and watch them playing poll, so when they was playing and smiling each other, Phillip put back his cup of juice and the thing he was using to play that poll on the green table and left by going to urinate, so when he was inside the toilet urinating, Austin Girl friend came where he was, then, stand up in front of him and look at him, so when he turn back and directly saw her, he jump over as the way he was scared, then she laugh at him out loud.

Jennifer

Ha ha ha...

And Phillip ask her strangely.

Phillip
What?

She reply by going.

Jennifer
Nothing.

So Phillip began to go back where he was coming from, to continue playing with his friends, and Austin girl friend Jennifer was following behind by touching up his back, touching his ass, and everything private on his body, but as for him he was trying to run out from her, until she push him on the wall, and that same time, Austin said to the others he was coming too, and then, went outside, and began to go and met where Phillip was, so when he was still coming, Jennifer was trying to kiss Phillip and Phillip was trying to push her away from him, and suddenly, Austin reach there \when Jennifer finally kiss him, and Austin saw it and began jealous and Phillip saw him, same thing with Jennifer, then Austin became jealous and left, but Phillip decided to follow him up by trying to explained him everything, but he wasn't listen to Phillip while Jennifer left them and began to go out, but when she was going out, she met Amber face to face and push her, then Amber look at her strangely and ask her.

Amber
What?

Jennifer
Nothing.

Smile and continue going, then Phillip who was behind Austin, was trying to explained to him and saying.

Phillip
Wait Austin, please wait, it wasn't my fault at all, please try to understand me, I wasn't wanted to hurt you this way, please, Austin try out and understand me, please.

Then when he was wanted to hold Austin on the shoulder by touching him, directly, Austin turn back and look at him and said with a lot of tears coming out from his face.

Austin
What! You think I haven't see anything you was trying to do? You think so?

Phillip trying to explain to him by continue saying.

Phillip
What you have just saw there wasn't my fault, but her fault.

Then Austin began to touch his head and saying.

Austin
Oh oh oh oh….; ha ha ha, are you kidding me? Huh? Are you? I watch you, and it was.

By pointing now his finger to Phillip chest and continue saying. (You trying to take off my girl for me, by trying to kiss her up and making her feel that you was better than me, it was you Phillip, it was you). Then Phillip became angry too and directly push Austin hand away from him and by saying.

Phillip
Stop! Okay! Just stop that, don't you see Your blind?

And Austin immediately became confuse at his question and ask him back when the others classmate was coming out to see what was going on between they both of them.

Austin
What? Blind? Who? Me?

And Phillip point at him with out touching him but by saying.

Phillip
Yes! You. Your blind, and your saying what you haven't really see.

Austin close up his hand and strongly with anger had said to Phillip.

Austin
Oh!!!.You know what? Your mad.

Then box (knock) Phillip on his cheek and Phillip fall down while they others classmate became surprise and said shout over like.

Classmate
Oh oh oh oh!!!

Then Phillip who was still on the floor after listen to his classmate shouting over, he then stood up from the floor immediately, and then box (knock) back Austin on his own cheek, and the classmate, specially they girls shouted back.

Classmate
Oh…..

While, Amber reach where those classmate was, the others boys like William, and Teddy began to ran over where Phillip and Austin was to stop them fighting, and immediately, Austin Box (knock) Phillip again on his cheek and they both began to start fighting and fighting, while Amber reach beside Angel and ask her quickly.

Amber
Hey! Have you see Phillip? And beside what are you guys watching here?

Then Angel point her finger toward where they fight was going on, and by answering back very fast.

Angel
Here he is.

Then Amber look down and became so surprise by watching good friends fighting all over, then she ran down, and while they others friends like William and Teddy was holding them, (William who was holding Phillip and Teddy holding Austin), then when she reach on their side, that is how they others classmate was coming where the fight was taking place, and Amber shout to them by saying.

Amber
Stop!

And by pointing her hands and trying to stop them fighting by separating them and saying to them with anger, while the two others was still holding them strongly. (It's not by fighting each other, that you both will result your problems, but it's by sitting some where, where there is a big silence and find out a way how to handle this prob, besides, how does this shit began?). Then Austin push away teddy behind him and reply back to Amber.

Austin

I will no longer stay here and answer back to your question.

Then started going home while Amber ask him back.

Amber

But talk to me, for me to help you out so that you shouldn't be angry anymore.

Then by keep going, he turn back and look at her by still going out from her house and saying.

Austin

Ha! Help me? You should better help your lover before searching the way out to help too. Then, turn back and continue going, and she look at the others classmate strangely, for 10 second, before saying to them.

Amber

Guys, it's better that you people should go.

Then shout out loud and said. (The party is over, the party is over). Then came near teddy and William and said to them. (Please guys, help me out to send this people out from my house, please). Then teddy and William began to use their hands and by telling them to go out and by driving out and by shouting and saying.

William

Hey friends, we have to go.

The same time William was driving them out and by saying that word, teddy himself was saying too.

Teddy
It's better we should leave Mrs. And Mr. Johnson to
solve their probs together.

*William began to laugh at teddy word wile those
classmate was keep going out from the house, and
when they was all going out, Amber and Phillip who
was still sitting on a big stone in front of the
balcony directly Phillip first stood up and began
to work over that place and Amber stood up too and
began to follow him then she ask Phillip.*

Amber
Tell me Phillip, what exactly was going on between
you and Austin?

Phillip
All this shit happen because of Jennifer, she's the
one who causes all this trouble.

Amber look at him strangely and she ask him.

Amber
Why? And how?

Phillip reply by still working out with Amber
through the living room.

Phillip
Cause of her sexual mentality, she wanted me to
have sex with her.

Amber stop working, then hold Phillip hand and said.

Amber
What? Is she mad or something?

*Then Phillip continue working and she follow him
and Phillip reply back.*

Phillip
For me she is, you know, I didn't knew Jennifer could be like this. And Amber reach inside the living room with Phillip by still speaking to Phillip.

Amber
Neither me, but about this, don't worried, we are going to try a way to convince Jennifer to spoke the true in front of all of us.

Amber's maid came into the living room and she was so surprise to look at Phillip mouth and nose bleeding and she put her hand on her mouth and said.

Maid
Oh my gosh, what happen to you?

Then Amber stood up and ask to the maid.

Amber
Please is it possible if you should remain right here with him? While I'm going to take some alcohol?

Maid
Okay ma'am.

Then Amber stood up and began to go into her room, then look for the alcohol while her maid was looking at Phillip nose strangely by keep saying to him. (Aw… that so bad). Amber reach inside the living room and when her maid saw her coming near Phillip, she left them both and Amber finally sitted in front of him to the next chair who was in front of Phillip, then she began to put alcohol on his sickness by trying to hill him, while she was putting alcohol into his wound, Phillip began to shout the way it was paining him like.

71

Phillip
Aie!!!!!!!!!

And Amber smile by saying over to him.

Amber
Oops, I'm sorry!

Then continuously putting the alcohol into his wound slowly, after healing him, she then stood up, then hold his hand by helping him standing up too, so she said over to him. (Let me bring you back home).

Phillip
Okay!

Then work out with him outside, so when they both was outside, she help him out get into the car, then, turn on the car, and then drive the car outside the house, but when she was wanted to reach outside the house, directly, some policemen reach behind her car, and they 2 policemen who was inside their cars came out from it, then, Amber off her car and those policemen stood up in front of the window of her car and they knock up her car door, and one of those policemen say to her while Organ and his friends reach behind them but by hiding into grasses.

Policemen 1
FBI, please madam, can you just put down the window from your car?

And she agreed and put it down, then the same policemen use the light of his torch by pointing toward her and said over to her.

Policemen 1
Hey! Who's that?

The she turn back, look at Phillip and answer back to that same policemen.

Amber
It's my cousin.

Then, the same policemen directly point that same light of his torch very higher to Phillip, and Phillip became frighten cause of that light and then, put up his hands by hidden his face so that the light should not destroy his face and the 2nd policemen saw that and shout over to Phillip and replying to him.

Policemen 2
Man, put down those hands right now

Then Phillip put it down and the 2 policemen point his own light toward Phillip eyes and saw Phillip wound and shouted to him and said. (My friend, get out from the car, now).

And Amber ask him.

Amber
But why?

The 2nd policemen became angry on Amber question, and shouted over to her by saying.

Policemen 2
But why, what??? How can you ask me such type of question?

Then directly upon up the door where Phillip was sitted, while his own friend was also doing the same thing by opening Amber own part of door, so hold their hands by bringing them out, and directly Amber shouted to them and said.

Amber

It's okay! Ill come out on my own

She remove her arms from that policemen hands, at that same moment, Organ and his classmate friend who were watching them began to mocked(laughing) at them, then when Amber and Phillip was out, the 2nd policemen ask to Phillip.

Policemen 2

What happen to your face?

Then Phillip reply back.

Phillip

It was and accident sir.

Then the 1st policemen ask them.

Policemen 1

Beside, what are you guys doing here in this time of the night?

And the 2nd policemen ask his own question when the 1st one was finishing his question too.

Policemen 2

Specially students if I may ask.

Amber and Phillip became so scared by directly replying at the same time

Phillip and Amber

No! we are not students.

And Phillip smile and said to them.

Phillip

We are Just simple humans being trying to.

Then the 1ˢᵗ policemen stop back his word and said to him immediately.

Policemen 2
To what? To steal, or to go to night clubs while others are resting by waiting for the next day to go to school? Isn't it?

And Amber look at them and directly said.

Amber
No! that isn't what he was wanted to say.

And the 1ˢᵗ policemen ask them directly.

Policemen 1
Okay, if you guys aren't student, then can we I see your identity card?

And Amber smile, same time Phillip did it too, and those policemen smile back at her the same way they both was mockery at them(policemen), then, the 1ˢᵗ policemen remove out his handcuffs and hang it on Amber hands while the 2ⁿᵈ policemen did it too, while Amber began to ask him.

Amber
Hey! What are you doing?

By shouting like that, the 2ⁿᵈ policemen put up his own handcuffs to Phillip hands, and Phillip was shaking up and trying to push him, while those policemen was doing their best to bring them into their car, until the finally put them inside their cars, and Phillip ask to the 2ⁿᵈ policemen with anger.

Phillip
What are you guys up too? Where are you bringing us?

Then the same policemen (who was the 2nd policemen)
turn on his car and answer to Phillip.

Policemen 2
As you can see, I am bringing you to jail, and from
there, you'll explain to us and to your father, what
you was doing with a girl older than you 5 times
your age, and specially at this type of the night.

Then Phillip shouted, while the 1st Policemen was
already going with Amber by seating behind
her while she was saying to him.

Amber
I promise you, if my dad heard that you guys
treated me this way, he will become very angry, I
promise you.

At that same moment she was speaking, Phillip was
shouting toward that 2nd policemen back
with a scared voice like.

Phillip
No……, not my dad

And that same policemen in front of Phillip smile,
then continue driving, at that same moment, Mrs.
Jane and her husband on their side was already
trying to go back to bed while saying to her husband
by sleeping on his legs and watching TV.

Jane
Babe!

August
Yes!

Jane

What do you think if we should go out and look for him?

August

Who?

Jane

Phillip of course

Then, August directly look at his wife strangely and reply back.

August

Why going out to look at him? Is he a kid?

Jane directly stood up from her husband legs and shouted over to him.

Jane

What? How can you say such types of things to your son? Have you forgotten, he's our only and 1st son we have?

August

I know that, but have you forgotten that since this morning Phillip has becoming brilliant? Not only in school, but also through that, God has gave to our son, greatest friends that will take care of him specially in any type of bad situations.

Jane directly look at her husband then began to work towards the kitchen.

Jane

No no no no no... I wouldn't sit right here, and watch the live of my son destroy by fake company's through cigarette or alcohol.

Then her husband stood up from his own chair, directly follow his wife back and shouting over to her.

August
For God sake, who told you that the life of our son will be destroy just like that, he isn't stupid as you think.

His wife remove her jacket from the wall, put on that same jacket on her skin, at that same time she was doing that, she was saying to August this.

Jane
No no no no, I wouldn't sit right here and watch my son to be destroy by fakes enemies, I myself, I have to go out and look for him.

Then while she was wanted to put on her hands into her pocket by trying to remove on her car keys, her husband directly reply to her by holding her hand.

August
Babe, look at me.

Then she look at him and he said.

August
Is not by going out and look after him that will change everything, but is to remain strong and wait that he should call us.

Jane
And if he doesn't do that?

August
Then we will call him our self.

Mr. August phone ring, then he left his wife, went back towards the table while his wife was behind him, so he pick up his phone and answer the call and said. (Hello!) Then the person on the phone who was inside the police station reply back to him with a woman voice.

Phone
Hello sir! Is it Mr. August Johnson?

August
Yes! How can help you?

Phone
As you can see, your son Phillip has been keeping into the prison of 1.6 police station for 30 minutes now, so we are waiting for you to come and pickk him up sir.

Then August look at his wife strangely and reply back.

August
Okay! I'll be there ma'am.

Then off the phone, and his wife approach over to him.

Jane
What's wrong? What's going on?

Then took the phone to August, and August reply back with a sad face.

August
If I tell you this, I'm not sure you'll be happy to listen to me.

Jane put back the phone on the table by asking back.

Jane
But why? Was it something about Phillip?

August shake his head the sign of yes.

August
Uh Huh!

And she tremble and began to bring tears from her eyes and by saying to August.

Jane
What happen t my son? Where is he August? Tell me, what happen to him? Oh my God, where is he now?

Then August reply.

August
In jail.

Jane
Isn't what I was telling you? and you didn't listen to me, I f we was already going since 5 pm to look after him, he wouldn't be watching himself sited into that scary place, oh baby, I'm coming for you.

At that same moment she was saying that, she was also going out from the house by going through her car, and August was asking her behind.

August
Hey! Wait for me dear, where are you going too?

Then turn back, look toward the door of his house and said to his daughter. (Jessica, please lock the door behind us). When he was shouting to Jessica,

at that same time, his wife was still working fast toward the car and saying to him.

Jane
What type of stupid question is that?

Then, they both reach inside the same car, and August hold Jane hand and say to her.

August
Wait! You aren't suppose to drive on this your condition, let me drive.

Then she look at him for 15 seconds while he was still trying to convince her to let him drive by saying. (Please dear, let me drive this car for God sake, please…..). Then she shouted back and replying to him by going out form the car and taking his place while August was also going out by going to take Jane place, and Jane was saying this to him while she was going to the other side of the chair of the car.

Jane
Okay! I'll let you drive, but please hurry up.

Then when they both was very well sited inside the car, he turn on the car and drive it to the prison way(road), then when they both was still coming, Phillip was there touching at his hair and was trembling by working round and round inside the jail he was and saying to himself by using a little voice.

Phillip
Oh my God, what are my suppose to do? Or what type of explanation are my going to tell my parents, God help me, help me God.

Upon saying that, his other friend, Amber was sitting on the bed but in a different jail, and she was there laughing and thinking about the good things she had we August into school and outside school, then smiling, and suddenly, a police woman, approach himself near Amber door, and she speak up by opening the jail door and saying.

Police woman
Mrs. Amber Ortega, the daughter of the governor of LA, Your lucky people doesn't know you into this state, as you can see.

Then by bringing her out from jail and finishing her last word. (Your uncle Devon is right there waiting for Ya, and he has even pay for your coming out). By eating her chewing gum and bringing her out, when she finally reach out, that police woman left her, and she ran and embraced her uncle and by saying to him with happiness.

Amber
Oh! Thank God you came.

Then her uncle look at her and said.

Devon
What the hell your doing here? Is it true you, they saw you out from the house with a kid.

Amber look at him strangely and answer back.

Amber
Which kid? I wasn't with any kid, so who told you such things?

Then her uncle change the answer to something else and reply back to her.

Devon

You know what! I wouldn't sit right here and reply back to your questions, so let's get our ass out from here.

Then while going out from the prison, directly, Amber Stop working and said to her dad

Amber

Please wait!

Then her uncle Stop working, then look at her and said.

Devon

Wait! What for?

Then she smile back at him and said to him.

Amber

I'm so sorry to say this, as you can see, I haven't brought here alone, so is it possible if you should help me out, pay up my friend bail too?

Then her Uncle Look at her very strange and said

Devon

Okay!

Then she became very happy and Jump over him, then Hug him up and kiss him on his cheek by saying to him.

Jane

Thanks uncle Devon.

Then she went with her uncle near a secretary dressing up as a police woman, and she said to that

secretary. (Umm… hello!). Then that Secretary Look
at her strangely and answer back.

Secretary
What or how can I help you?

Then Amber answer back.

Amber
As you can see, I was brought here with a friend,
and I seriously want to ask, what is the number of
his jail?

The Secretary began to upon up the book where the
prisoners names was writing in it and by asking Amber.

Secretary
What for if I may ask, and why do you want to know?
And what is his name?

By still looking on those names and Jane reply back.

Amber
His name is Phillip Johnson, and I brought here
with him

Secretary
Okay!

Then when she finally saw Phillip jail number, she
Look at Amber and said to her. (Is 185). Then Amber
reply back by running over that place.

Amber
Thanks.

Then, the same secretary ask Devon by putting her
glasses down from her noses and asking.

Secretary
Sir. What can I do for you?

Then Devon reply back.

Devon
Hmm…. I'm here to pay up that young boy bail.

Then directly, he remove out the money from his pocket, while Amber reach in front of Phillip door jail, and Phillip was there knocking his head on the wall, directly, when Amber look at him doing that, she became so shock(surprise) on the way he was behaving and she shouted over his name, and said.

Amber
Phillip!

Then Phillip jump by tuning round and looking at the person calling him and he ask her.

Phillip
Oh my God, Your out already?

By approaching near her, then hold her on the hand and ask again. (Who brought you out?). She smile at him, then he began to cry and say. (Please…. Help me to get out from here, please… I don't belong here for real, so please help me out Amber please). Then she said

Amber
It's okay Phillip, it's okay! My uncle Devon it's already paying your bail for you to get out from here too, so please, hold on.

Then directly, the same police woman who brought Amber out from her jail, came to remove Phillip too,

while Amber turn and look at her coming and then said to Phillip. (Thank God, she is here.) Then she finally approached and remove up the key who was on her uniform police trouser, then upon up the jail where Phillip was inside, and Phillip came out from there, then, directly, when Phillip came out, he jump over Amber and they both hug up, and then she hold Phillip hand and they both came out, so when they reach where the secretary and Mr. Devon was, she said to her uncle.

Amber
Here we are.

Then her uncle turn and look at her and saw her standing near Phillip and was so shock to watch her standing near Phillip and he came in front of Amber, hold her on her arms then brought her near into a place Phillip wouldn't be listen to their conversations and he ask her.

Devon
For God sake, what are you still doing with such type of a man?

And directly, Amber Look at her uncle strangely and reply back.

Amber
What you mean by that?

Devon lift her arm and reply to her.

Devon
Amber, don't you see that guy is younger than you? He looks 13.

Amber smile and reply to her uncle.

Amber

No dad, Your doing a mistake, he isn't younger. He's older than 13.

Then her uncle answer back by making his mouth as a baby.

Devon

Okay! As you are saying he looks older than 13, how old is he seriously?

Amber

Sixteen Uncle Devon.

And her uncle who became so shock again reply to her answer.

Devon

Ha ha! You say sixteen? Don't you see your older than him four times? Come on Amber, your just twenty, and he's 16 and you aren't suppose to have some friends like that, come on.

Jane show up her sexy body to her uncle by opening her clothes and showing her sexy stomach and asking to her uncle with a smile that.

Jane

Do I look old or ugly?

And her uncle became shock by looking her differently now and he answer back.

Devon

No! that isn't what I wanted to ask you.

Phillip parents reach inside the prison, and Phillip mother saw Phillip standing beside of a wall,

while her husband was looking to the other side of the prison, and by turning to his right, his wife directly shouted Phillip name by running toward him and was saying.

Jane
Phillip!

Then Phillip look at her by saying to himself.

Phillip
Oh oh, I'm finished.

By showing a small smile toward his mother, and his mother just approached in front of him while Amber who listen to his mother calling him and August too, both decided to ran over Phillip, so when they both was near Phillip, Mrs. Jane was asking Phillip such question like.

Jane
For God sake, can you tell me what your seriously doing here?

And Amber ask Jane this question.

Amber
Hmmm… Sorry if I may disturb you a bit ma'am, are you Phillip mother?

Then Jane look at Amber strangely by answering to her question.

Jane
Yes, I am! How can I help you?

Then Amber smile and began to leave that place with her uncle and saying.

Amber
Nice to meet you, bye!!!

Then continue to go out while Mrs. Jane was trying to ask her

Jane
But, wait!

Then August look at his son with and angry face, and said to his son.

August
You know what? let me first go there and pay up your bail, before you'll tell me what your doing inside criminals home.

While he was wanted to go and pay, Phillip straight up his hand toward his dad very fast by saying.

Phillip
Dad!

When his dad turn back and look at him, he directly put down his hands but by putting his fingers into his mouth and replying back by doing as a baby of 5 months. (You don't have to pay anything anymore). And his dad came back to him by asking him.

August
Oh….. why should I not pay anything? Because the money you have stoling from the bank help you to pay up your bail right?

And Phillip who was still scared answer back to his dad.

Phillip
No dad, that isn't true at all.

And his mother hold him on the arms, and began to work with him toward the door from the police officers by getting out there and asking to him with anger too and her husband was behind following her while her question was this.

Jane
Then if you haven't steal anything, what can it be then?

Then when they both was near the car, she and Phillip stop working and she look at him with a strange face and said to him. (Oh.. don't tell me your now stealing people wife?).

Phillip
No! I don't do such things mom.

Then her mom saw those glasses into Phillip t-shirt, and she ask him.

Jane
What the hell is this?

Then when Phillip was trying to explained to her that it was glasses, she remove it from his tshirt and throw it into the dustbin and Phillip shouted.

Phillip
Nooo...

Then his mother push him into the car, and get into it too, while the husband enter inside the car too and they husband on the car, then they left, and Phillip cry and ask his mother this question by

bringing tears from his eyes. (but mom, why have you done that?).

And her mother ask him.

Jane
Done what? I should be asking you myself that same question.

Then she turn her neck and look at herself and said to him. (Tell me Phillip, what have we done to you?). Then Phillip look at his mother and said.

Phillip
Mom, I'm serious, those glasses you just throw was something so special to me, very special. Then August said to Phillip.

August
If those glasses are so special to you, then why don't you go back in the morning and peak them back? Suddenly, Jane beat him up on his labs(legs) and said to her husband.

Jane
Stop that.

Then when they reach into the house until the came out from the car, Phillip directly ran toward the house, and came inside, saw his sister standing near the stairs of the house, then he ran inside his room without saying anything to her and lock up the door of his room and the door make some loud voice and his mother shouted to him by saying.

Jane
Please, don't broke that my door for me.

While her husband was closing the door of the house, Jessica came near her mother and ask her with a sad face.

Jessica
Mom, is he angry against me?

Then her mother smile and carried her up and answer by kissing her on her cheek.

Jane
No! he isn't.

Jessica
So why has he not greeted me when he just came in?

Jane
Because he's angry against your dad and I babe, not to you.

Then her husband came near to them and kiss them on their cheek and said.

August
Okay babe's, I think I have to go back to bed too.

So while going and after kissing them. Her wife shouted over to him and said.

Jane
Okay sun, I'll meet you there very soon.

Then she took her daughter inside her room, and put her on her bed and then she said to Jessica. (Okay love, should I tell you some good story's?). And Jessica reply with a smile.

Jessica
Yes mom, I really want too.

Then Jane took up some of Jessica books who was behind her back and ask Jessica.

Jane
Which one should I read first? The song of kindest or funny sky sixteen?

And her daughter reply back by pointing the book of funny sky sixteen and saying to her mother.

Jessica
This one mom.

And her mother shake on a happiness way and reply to her daughter.

Jane
As you wish mistress.

Then began to read t and read it until the next day, she was already having her head on her daughter bed, and sleeping, while Phillip lock up the door of the house and it sounded louder, and Jane directly jump up from the bed of Jessica by asking to herself. (What the hell was that sound?) Then look at her daughter still sleeping and left the room and went down stairs to look what was going on, when she reach down, she saw her husband trying to go out too by running toward the door because he was so late, and she directly ask him louder. (But are you not going to eat first before going out?). And he reply back to her louder.

August
Sorry angel, I wouldn't eat this time, I'm late.

Then she reply back.

Jane
As you wish!

Then when Phillip was inside the taxi trying to go back to the same place to take back his glasses, Amber call him on the phone and he answer it back and said.

Phillip
Hello!

Amber
Where *are you?*

Phillip
I'm on my way!

Amber
Hurry up, cause the next exam will start sooner.

Phillip
Okay! I promise you. I'll be there during 21 minutes.

Amber
What for? And why?

Phillip
As you can see, I'm trying to do something very important, and I promise you, I'll let you know when I'm there.

Amber
Okay! I hope so.

Then phone off, and Phillip began to tremble and ask to the driver (taxi man).

Phillip
Please sir, drive quietly, I'm late.

And the driver answer back.

Driver

I know you're late sir, and I'm doing my best, so calm down.

And he was there driving and driving the best he can to bring Phillip to the place he was wanted to be, so when they both reach there, Phillip came out from the taxi and said to the taxi man.

Phillip

Please wait!

And the driver answer back.

Taxi man

Okay sir, as you wish.

While Phillip was running into that dustbin, so when he reach near the dustbin, he put on his hands into it and began to look search at his glasses, and people of the street was passing their way and watching at him strangely, and some was saying. People Disgusting…. And Phillip directly found out the glasses and then jump and saying and smile, turn and look at those who was looking at him strangely and ask them.

Phillip

What?

Then those people continue their way as if nothing was going wrong, then Phillip went inside the taxi and he said to the taxi man to drop him to school by giving the address of his school and the driver did that and went and left Phillip there. So when Phillip reach there, he remove from his pocket some few amount and gave it to the driver and ran inside the school, then went beside the door of the classroom, call Amber who was looking at students

speaking and he said with a small voice for others to not listen to him.

Phillip
Amber… (speaking with a little voice).

She turn round, look left and right before looking behind and saw that it was Phillip, stood up from her chair and began to work toward him and Phillip ask her. (Am I late?) And she said.

Amber
No! You're not late, but where were you?

And Phillip began to bring her inside the toilet by saying.

Phillip
Just follow me, what I have to tell you, isn't good if I say it to you right here.

Amber
Okay!

Then the work toward the toilet and Phillip look behind if they was follow them on the back, so lock the door and firstly, remove the glasses form his bag and show up to her and she saw it dirty and she ask him. (Gosh! What happen it?). And Phillip explain

Phillip
This is because of my mom, as you can see, none of my parents knows that I wear such type of things in school, so when my mom saw this thing into the pocket of my t-shirt, she then thought I was show-off.

And Amber directly reply to him.

Amber

That's why she throw it?

Phillip

Yep! So tell me Amber, what do you think I should do? It's dirty, and as you can see, I can't watch such things use by current.

Amber began to think and by saying

Amber

Hmm….. what if you try?

Phillip

Try what? Watch this thing?

Amber

Yes! Just watch it, and if they thing destroy, then we are going to look for something else to help you out.

Phillip

Something like what?

Amber

Don't know, just do it.

By approaching near the wash hand basin, Phillip who was still scared and said.

Phillip

What happen if he really destroy? Means this exams that is really coming, I'll fail it.

And Amber said to him.

Amber

Don't be scared and do the fucking thing Phillip.

And Phillip finally upon up the toilet pomp and water came out and he began to wash it and wash it, and after that, he close it up, took the glasses back and came near Amber who took the glasses from him and wipe the water from it through the tissue, then give him back and said to him. (Wear it, let us see). Then Phillip took it from her, wear the glasses back, then she ask him. (What do you see?). And Phillip ask a question through his brain who was.

Phillip
Give me the meaning of voltage?

Then the glasses came on, and wrote a question through it, and it was writing.

Glasses
What's your password?

Then Phillip smile and show up his finger to Amber on the sign it was working, then remove it back from his eyes while she smile back to him, and she took him and left the toilet by saying.

Amber
Let's go back to class.

Then Phillip follow her back, when they both was already coming closer the door of the classroom by running, they directly heard the teacher speaking by sharing text paper, and the teacher was saying this while the was both approaching little by little.

Teacher
This exams will be the most strongest you guys has never made it before, so what I suggest you to do is.

Amber and Phillip came inside the classroom by opening the door of the classroom very little, while Organ was looking at them coming inside and turn and look at his friend nick and ask him with laughter.

Organ
Where exactly this 2 monkeys went too?

Nick laugh at Phillip face, and ask to Organ.

Nick
Oh… have you notice that, Phillip face look the same as Austin face?

Organ immediately look at Austin face by asking to nick.

Organ
How?

Nick
I'm talking about the same wound, they both have on their faces.

Organ
Oh, they had a fight!

Immediately, Organ and nick directly laugh out loud, and, shut down their laugh a little by looking at the teacher. then, thinking that they teacher who was giving the paper to the last students didn't saw them, when Phillip and Amber was wanted to go and seat on the corner of a window, the teacher directly said Teacher Were are you both coming from? And Amber and Phillip began to make

Phillip and Amber
Hmmm……..

And *Phillip who was touching his hair and by doing as a innocent guy directly said.*

Phillip
Hmmm… well, ma'am, as you can see, I'm the one who ask to Amber, to come out with me and help me do some few things before we should begin the exam.

And the teacher who was so shock at his word, directly said.

Teacher
Aw…. Poor boy, you both think I'm stupid? Huh! Well, I'm going to change the both of you, cause I don't think, you both have to sit on the same bench to do this exam.

Then directly, she turn round and she look at angel wearing her glasses on her eyes and she shouted at angel and said. (Angel). And angel reply back.

Angel
Yes Mrs. Dorothy.

And the Teacher reply back.

Teacher
Stand up! And fast.

Then angel stood up very fast and began to tremble, then the teacher hold her hand very fast and brought her out from where she was sitting, then say to angel faster by pointing her finger to Amber place. (Sit there) While angel was going to seat on Amber bench, she turn her same finger by pointing it on angel bench by saying to Amber. (Amber, that will be your new place for now). Then Phillip smile by asking to the teacher to a funny way.

Phillip
What about me Mrs. Dorothy?

Then she look at Phillip strangely for 3 seconds before answering back.

Teacher
Huh? About you how? Get your ass back on your place.

Then Phillip began to work toward his bench, went and seated there, then, they teacher gave them their own paper of exam, and they teacher then look on her wrist watch to look what time was it before the hasn't ring the bell of the school yet, then, directly, the bell of the school ring up, and she said to the students. (Turn back your papers and start. I give you 1h to finish this exam). Then all the students turn back their papers and they began to start writing, while Phillip put up his glasses and began to ask into his brain one question he saw on the paper, then the glasses ask him.

Glasses
Welcome Phillip Johnson, what's your password?

Phillip
Amber rose.

Glasses
What's your user name?

Phillip
Phillip Johnson.

Glasses
Welcome to the base system of Chang technologies.

Then Phillip directly started asking through his brain the questions writing into his paper by

using his same brain(mentality) then the glasses was giving him all they answers, so, that is how everyone written their exams still they exam got to and end, then, when everyone was already out, Phillip, began to run out from the school by going to meet Amber, but while running, he turned and look at angel who was talking to some of her friends beside the door of school, and he ask her.

Phillip
Angel.

She turn and look at him, and Phillip ask her. Have you seen Amber? *Angel reply back by pointing her fingers on the way Amber was and saying.*

Angel
Yep! She's on that side trying to call someone on the phone.

Then Phillip ran toward that place by saying to angel.

Phillip
Oh! Thanks a lot.

Then angel turn back and look at her friends and continue their conversation, while Phillip was reaching near Amber, and when he got his ass there, he speak louder by calling Amber. (Amber). *She turn back and smile, then Phillip approach and kiss her on her cheek, then ask her* (Hey! What are you doing here?). *Amber standing away from the school a bit and her car too, answer Phillip back.*

Amber
Hey! How was the exam? Specially with those glasses, I hope you'll be having a good mark on it?

Phillip smile and answer back.

Phillip
Oh yea! As you say so, I will, *(doing a strange face and continue saying)* but hope you aren't angry that I wasn't on your side to help you?

And she knock him on his shoulder by smile and saying No! Then Phillip was feeling hurt and he reply the way it was paining him.

Phillip
Ouh…

And then continue saying with out showing any pain again. (So who was you talking too, on the phone?) And Amber reply back with a little sadness on her face, by putting her head down a little.

Amber
With my dad.

Then Phillip notice that she was a little sad, then hold her chin by making her to look up toward him, then ask her.

Phillip
Why this sad face? Are you okay?

And she smile a little, while he was living her chin and she reply back.

Amber
Oh yea, I am.

Phillip transform his own face because he was so shock on her new behaving and ask her again.

Phillip

Then if your okay, why this sad face? Amber smile again and reply back.

Amber

Sad face? I don't have any sad face.

Then Phillip said to her.

Phillip

Okay, can you tell me what is really going on? Hope it isn't because of the exam we did this morning?

And reply back to him.

Amber

But no.

Phillip

Then what is it?

Amber

It's all about my credit card, my dad want to take it from me.

Phillip

Take it from you how?

Amber

He want me to give it to the principal, and I don't know what I'm going to do without it, I'm serious, I don't.

While discussing each others, Mrs. Dorothy was coming outside the school, then when she reach outside, she saw angel who was still discussing with her friends, and she finally ask to angel.

Teacher
Angel.

Angel and her friends directly turn back and look at the teacher and reply to her politely.

Angel and her friends
Hello Mrs. Dorothy.

And the teacher put her smile on the same way but still feeling angry.

Teacher
Hello my little sunshine's.

Then close her smile and ask angel louder. (Where the hell is Amber?). And angel who was so scared point her fingers toward the same place where Amber and Phillip was by answering back.

Angel
On that side ma'am.

Then teacher smile gently and reply to angel.

Teacher
Thank you.

And left them, while angel said.

Angel
Oh God.

Then, the teacher began to work very fast and very fast, when she saw Amber and Phillip discussing and Amber who was saying to Phillip.

Amber

I think I have to obey my dad and give back the credit card to the principal.

While suddenly, the teacher directly shouted by calling Amber on her name.

Teacher

Amber, Amber, Amber, Amber.

Amber turn back and look at Mrs. Dorothy coming and she said slowly toward Phillip ears.

Amber

Not again.

Then Mrs. Dorothy reach where Amber was and she said to Amber.

Teacher

Amber. You wait inside the principal office.

And Amber reply back.

Amber

Okay ma'am.

Then, Mrs. Dorothy went back to school while Amber said to Phillip.

(Well, Let's go) Then directly follow back the teacher, and enter inside the school, then when they both was still getting them selves inside the principal office, they finally saw Organ, who was sitting on the bench with his friends discussing, then Organ saw them passing, stood up immediately with his friends and check who if they wasn't dreaming watching Amber and Phillip passing on

their corner, so when they saw that it was seriously them, Organ laugh at them

Organ
Oh my God, who are we seeing here? Mrs. And Mr. Johnson going to back to prison for something they didn't do.

And he began to laugh out loud with his friends like devils.

Organ and his friends
Ha Ha….

But while Organ said about going back to prison, Phillip who listen to that directly ask Amber.

Phillip
But how did he knew we both was in jail?
And Amber reply back.

Amber
Don't know.
Then when they both finally reach inside the principal office, then, the principal who saw Amber and Phillip came in together directly said to Phillip.

Principal
Sorry man, I call one person right here, not two.

Then Amber turn back and look at Phillip and said to him.

Amber
I think you have to leave alone.

Phillip look at her strangely and reply back.

Phillip
Are you sure?

Amber
Yea! I am, but please wait for me out side there, it wouldn't be taking long.

Phillip
Okay!

Then Phillip directly decided to go out side while waiting for her, when he was out, he seated on the long bench who was on the corner of the door of the principal office, so the principal Mr. James Cowbell who was still seated on his chair stood up and said to Amber to a seriously way that when he speak, he doesn't joke.

Principal
Sit!

Then Amber seated, and he said to her by working round and round into his office. (So is it true, your spending your dad money for nothing?) And Amber look him up and reply back to him.

Amber
No sir.

The principal continue saying.

Principal
No sir? Are you sure?

Then she reply back strangely.

Amber
I'm serious sir, the money I'm using is for my good and others people good.

So the principal directly reply back to her and very fast.

Principal
Lies, you think I'm stupid? You think your dad is also stupid? You think we doesn't know everything your doing with your money like bringing people into your father house and doing party while the students have to study? You think we haven't see you going to night clubs? You think we haven't see you buying some men's clothes and spending all your dad money on it? You think so? Huh? You think so?

And she shouted to the principal by saying

Amber
No No….

And the principal slow down he voice a bit and reach behind her, put his hand on her shoulder and started speaking into her ears and saying.

Principal
What does a man profit to the whole world by losing his own soul?

And stood up straight and then came back on his chair, then show up his hand toward her and said. (May I have your credit card?). Then she remove it from her purse and gave it to him, then he shake his hand asking her to go out by saying.

Principal
Now you can go.

Then she stood up and left, when she reach outside the principal office, Phillip approached from her, while she was working very fast toward Organ place, and Phillip was asking her.

Phillip
What happen there? Did he hurt you?

And she reply with anger.

Amber
No! he hasn't, but the person who did it, is Organ.

Phillip still working on her side and asking her.

Phillip
How?

And Amber began to explained to him by saying.

Amber
The principal just cease my credit card, because someone told him all the things I've done with it, like spending into party's clothes, clubs ba ba ba ba.

And Phillip was so shock and he ask her.

Phillip
But how did he know all that?

Amber answer back, by getting inside the class were Organ was.

Amber
Through Organ of course.

Then finally reach inside that classroom, when Organ listen his name coming through Amber mouth, him and his friends directly stood up by jumping from the bench they was and Amber approach her selves over to Organ and immediately box him on the nose, and Organ fell down, then his friends was wanted to attack Amber back, and she reply to them.

Amber

The person that will try to put on his fingers on
me will finally regret the day he mother bring him
on earth.

*They went back slowly and Amber said to Organ (Your
lucky I haven't cut off your dick, but next time,
I'll do that when you'll put on your nose inside my
things). Then began to go out side that place with
Phillip, while going, Phillip was there smiling.*

Phillip

God damn, you did it princess, you did it, damn,
I didn't knew you was so stronger this way... hmmm,
you did the best thing I was having inside my mind
to do it since if I could be like you.

*Then Amber who was still going outside the school
ask Phillip.*

Amber

Should I bring you home or let's go to my place
first?

*And Phillip stop working and then said to her, while
she also stop working and look into Phillip eyes.*

Phillip

No! not to your house at this time.

*Then they both continue their way by going out from
the school until the reach outside the school when
Phillip was saying to her. (As you can see, my dad
and my mum were seriously angry against me for what I
just did yesterday, so bring me home) So, by reaching
near Amber car, Phillip directly jump inside her car,
and Amber open the door of her car and then start
on the car, and drive toward Phillip house, on the*

next place of August who was into his office typing on his computer, directly, the general manager of the place where Mr. August was working in, directly came and open up August office door and went in, then he said louder with anger so that all the others people who was working there should listen to him shouting over August, and he was saying.

Director General

Mr. Johnson, I don't think this place is really the good place for you to continue working here.

Mr. Johnson who was so shock about his word jump up from his hair and look at his Director General by asking him.

August

Why did you say that sir? What did I do wrong?

Then the director general show him the reason who was a paper Mr. August type it wrong by answering back to August.

Director General

Look at this shit. you repeat it again, while I have warn you more than 1000 times to stop copying such things and send to me, who the hell you thing you are?

Then Mr. August stood up and ask for forgiveness by showing a sad face toward his director and what he was saying was thing.

August

I'm so sorry sir, I didn't mean it, I did my best to do what I could to bring out something very special for you and as for me, it was looking very perfect sir.

And the director show him that copy very higher to his face and reply back.

Director General
So you call this good typing ? I'm sorry to deceive you August, your fired, I said fired.

And August shouted and began to follow his director on the back by trying to convince him and saying to him.

August
No o o o o o….. sir, please you can't just fired me this way, cause by doing that, how are my going to feed my children's and wife? How sir, how?

Then the director stop working and turn back, look at him and answer to his question.

Director General
I don't know, just go outside there and look up for something better than this job, cause as you can see, it isn't every one who can survive doing only one thing, specially on something he doesn't like.

And continue working and August continue running behind him and saying to him.

August
But sir, who says I doesn't love my job? Of course I love it sir, I love it.

Some guardians came behind August and carry him up, and by bringing him out side the company, and August directly shouted toward the director ears continue saying the same word while they was bringing him out. (I love my job sir, I love my job, sir I love my job seriously). Then by reaching outside the big building,

the throw him on the floor, and he stood up, and decided to go back into his car with a sad face, and left. Then when Phillip reach in front of the house of his door, he started shaking his hand by saying good bye to Amber, so when he came inside the house by continuously saying good bye! He knock his legs on something very strong, and who was his mother legs, then fall on her, and immediately stood up from her by looking strangely to what makes him fall on the floor, directly, when he find out it was his mother, he directly ask to him self a little louder.

Phillip
Mom?

And continue asking again 2 times (Mom, mom). Then finishing saying. (Mom, is it you?). Then he goes down on his knees and began to shake his mother many times and asking to his mother.(But mom, why are you sleeping on the floor? Mom, mom, stand up please (with a sad face), please stand up, that isn't the right place for you to sleep on, mom). While saying all those words by shaking her and shaking her and by starting bringing tears from his eyes, he started speaking out loud by calling his younger sister Jessica. (Jessie, Jessica, Jessica, where are you babe, where are you?). Then Jessica began to come down from the stairs and while her brother was still saying. (Mom, what wrong with you? What wrong mom?). Then when Jessica finally reach in front of him, he said to Jessica. (Oh!!!! Thank God you're here, Please bring me the phone Jessie, do it quietly, please). Then she ran toward the home phone was keeping, and it was on the wall, then she took it and ran, by giving it to him, until he took it from her and call his dad on the phone, his dad who was still angry by driving his car angry and bringing tears from his eyes listen to the phone ringing, and he dint

peak it up, and Phillip continuously calling him and calling him many times by even asking to him selves that. (For God sake, where did dad keep his phone?) Then, stop calling his dad, and directly type the emergency number, and when the phone ringing, a lady spoke on the phone, Phillip reply. (Hello! Please it's Urgent, my mom can't stand up any more). Then the lady on the phone ask him.

Lady (phone)
Sir, do you know what exactly she had before falling on the floor?

Phillip (phone)
No ma'am, I don't, please, hurry, she will die if none of you come here fast.

Lady (phone)
So what's the number of your street?

And while Phillip was giving the number of his street, where he lived, Jessica was already bringing tears from her eyes by crying and still shaking her mom to stand up, then the lady on the phone said to Phillip. (Okay sir, we are going to send someone on the way right now, while that, turn your mother on the way she's going to look at the roof, then use a good pillow and put it on her head, and then put up one of her legs for her to breath the more she can).

Phillip (Phone)
Okay! I got you, but please do it quietly.

Then phone off, and Phillip ran inside the room, then took the pillow, came down, and turn back his mother the way the lady said to him, then put the pillow on the floor for her to put her head on it, then, took his sister, and his sister ask him.

Jessica
Phillip, is mom dead?

Then Phillip knee down on the floor and said to Jessica.

Phillip
No, mom isn't dead, she's just sleeping and resting.

And Jessica ask him back.

Jessica
So if she isn't dead, why is she not answering to me?

Phillip who was keep holding Jessica hand by saying to her.

Phillip
As you can see, mom is just tired, and that's why I have call a doctor to come and give her some injection for her to stand up and become very stronger, okay love?

And she agreed by saying.

Jessica
Okay!

And Phillip directly use his hands by wiping he sister tears by saying.

Phillip
It's okay, stop crying, okay! Stop crying .

Then he, stood up, and remove his phone behind his trouser, and call Amber through his phone, when the phone ring up for 10 seconds, Amber answer to him.

Amber (Phone)
Are you okay?

Phillip (Phone)
It's my mom Amber

And Amber became frighten and ask him

Amber (phone)
Your mom? What's wrong with her?

And Phillip reply back.

Phillip (Phone)
She just don't want to stand up, that's all I can say for you through the phone, so, why don't you come over my place and see it by yourself?

Amber (Phone)
Okay, I'm coming.

Phillip (Phone)
Please hurry up.

.

Amber (Phone)
Okay okay, I'm on my way right now.

Then phone went off, and directly, the emergency reach there, stop their car quietly, went inside Johnson house by running, then put the bed of the sick person on the floor, did their best to carried Jane on that bed, while Phillip was standing up holding his younger sister who was still trying, so, when those emergency has finished doing everything to Mrs. Jane on that bed, then, they directly carried the bed were she was on it, and decided to bring it into the emergency car, while Phillip came out from the house with his younger sister and close

it up with the key, then reach near those emergency people who was trying to leave that place with their emergency bus, then Phillip stop them going by standing beside the driver and said to them.

Phillip
Sir, please, what if I should follow you back?

Emergency driver
Sorry boy, we are late, you just have to follow us back, or come later with us to the hospital…..

When he finished giving the name of the hospital to Phillip, he start on the car and left, then Phillip went back with Jessica, and they both seated on the smallest stairs who was in front of their house, while waiting for Amber. On the other hand, Mr. August was inside a bar drinking some alcohol and speaking loudly to the other customers who were inside the bar.

August
Hey! Everyone listen, I caught my boss last night going inside the hotel with a woman who wasn't his wife totally. (knocking the cup of his alcohol on the table as if he has been losing his senses and continue saying) then when I met both of them, I said, "hey sir, what the fuck are you doing with the woman of some one else? Are you sure everything is okay with you? Are my not talking to you… Sir?"

All the people drinking and chatting into that bar immediately said " ooooooooh….."
Then this morning, when I reach at my job service, the guy came to me, and fired me out, just because I was right telling him all those things last night, you know what? I thought he was racist, but it wasn't so, he was just scared that I will be saying all

of what I have seen him doing to his wife, what the hell. Then after that, he fall his head on that table and finally slept after yawning. Then on the other side, Phillip was with his younger sister holding her into his arms. Few minutes after, Amber reach there with her car, and she came out, and ran toward them, while Phillip was standing up by approaching toward her, and when he reach near her, she look at Jessica, and she kneel down in front of Jessica and ask her.

Amber
Aw.. poor angel, have you eating something?

And she shake her head on the sign of no, then Amber stood up, look at Phillip and ask him. (How are you? Does your mom is still inside?)

Phillip
No, she just left right now through the emergency car.

Amber kneel down to carry Jessica and started going inside her car.

Amber
But what are we waiting for? Let's go right now.

Then Phillip follow her back, and she reach near her car, put Jessica on the back by putting her the seat belt, while Phillip was getting inside his own car and by putting his own seat belt, then she went too, and put it too, and then start on her car, and they left, while the other side, Mrs. Parker the history teacher was looking the way to convince the principal to give back Amber credit card, and she was saying to the principal.

Teacher

I suggest you to give back Amber's credit card Sir.

While speaking to the principal, they both was seated on their chair, talking each others and crossing their legs.

Principal

Why should I give back her credit card?

Teacher

Just for her to feed her self sir.

Principal

Who told you she's hungry?

Teacher

She doesn't have to tell me anything before you should give her back her credit card, as you can see, she live alone, and she has the right to use it the way she want, so sir, please for my own sake, give it back to her.

The principal stood up, by working toward the teacher and going round and round inside his office and by keep saying to her and saying into her ears too.

Principal

Beside, who told you I cease it to her? Or don't tell, me she call you on the phone and ask you to come and plead it to me?

Then continue working and by looking at her strangely, while she was looking at him too and answering to him.

Teacher

But no, that isn't true, well, everything that happening here, I always know sir.

Then she directly stood up from her own chair, and said to the principal beside his ears that. (Well, in the end, you'll find your self giving back the credit card to the poor girl). Then, she went out by closing the door on her back, while on the other place, Amber and Phillip finally arrived inside the hospital, then Phillip who was caring Jessica on his shoulder, decided ran toward the secretary who was standing there, so when he finally reach near her, he saw that, the secretary standing there was so fat and she was eating sandwich, then he finally ask her.

Phillip
Please ma'am, I'm looking for the room of that woman who just came here.

And the lady ask him differently that.

Lady
What's her name? and at which have she reach here?

Phillip began to tell all the info while the lady wasn't haven't his time by watching on the Tv who was on the wall of the hospital, and she was even laughing out loud, and Phillip was saying this to her.

Phillip
Her name is Jane Johnson, she just arrived right now.

And Phillip began to said it again to her by looking at her strangely and he was keeping saying. (It's Jane Johnson, and she just arrived right now, she's my mother, ma'am, what wrong?). While he was speaking to the lady by giving her all those information's, Amber saw that, that lady wasn't having Phillip time, then she decided to go and talk to that lady

her self, and when she reach near the woman, she ask to Phillip.

Amber
Let me try and see.

Then Phillip went back, while Amber knock her hands on the table at the same time shouting to the woman by saying (What the hell are you doing when some one is talking you, Woman?). Everyone who was inside the table seated turn and look at Amber strangely to her question, while the woman turn too, and look at people watching at her strangely, then she shouted to Amber.

Lady
Hey! Your not my mother, so what do you want?

Amber look at that lady with anger, then look on the book that woman was reading, and immediately she peak it in front of that lady, and began to work through the hospital rooms, while Phillip who was still having Jessica on his shoulder was following her back, and the old woman was there working on her back too and by shouting to Amber and saying. (Young girl, give me back that book, okay? Give me back that book before I should get angry with you). Amber who finally saw the name of Jane Johnson and the number of the room she was, immediately turn back when that woman finished her word who was " before I should get angry" and directly give that book to the woman and said over to her.

Amber
Take; I have seen already the number of the room.

Then smile to the lady and said. (Thanks). Then began to take the direction of the room Mrs. Jane

was into it, while Phillip was running behind her and by asking her.

Phillip
Are you sure of what your just talking about? Have you really seen it?

Amber who was continue going on her way, directly reply back.

Amber
Uh-huh.

Then, while she was still going by looking the numbers of rooms, directly, she saw it, and immediately enter into it, and Phillip enter into it too, then, Phillip who saw his mother still sleeping and by having many things on his nose and on her hands made by doctors, then, Phillip put down his sister, and ran over his mother, then, put his sister down, and knee down too in front of his mother, then hold her hand and began to cry, while his sister was pushing her mother and telling her to wake up, but nothing happen, and Phillip was also asking his mother to stand up, while Amber was feeling sad for them, directly after that 3 minutes they were inside there crying, the doctor who put all those things on his mother open the door of that room by coming inside and looking at them crying, then, he touch Amber on her shoulder and ask her.

Doctor
Are you okay?

And Amber reply back.

Amber
A little

Then the doctor approached him selves near Phillip and then touch him on his shoulder too, and then look at them all and ask them.

Doctor
Is your father still alive?

And Phillip turn and look at him and reply to the doctor.

Phillip
Yes, my dad is still alive, why such type of question?

Then the doctor said.

Doctor
Because what I have to say right now, should be said to your father or the head of the family.

And Phillip look at him strangely by directly replying back.

Phillip
But I'm her son. I mean, we all here are her children's, so why don't you say it to us now?

Doctor
Because, your dad will be the better person to understand me

Amber
Then doctor, speak, and we promise you, we are going to do our best to understand you, and try on to pay you anything if we can, so what is it?

Then the doctor who was a little scared finished by saying

Doctor
Okay! As you all can see, your mother is suffering from a seriously disease call pathologies, and it's a sickness that always affect people mentality over 35 to the end of their life, and that disease always turn some to be mad, or lost their senses, so, if we don't operate her fast, she will become one of them sooner.

Then Phillip became scared and directly ask the doctor.

Phillip
Doctor, how much should we pay you?

Doctor
$80.

Amber
$80? But where are we going to take such amount?

Doctor
Don't know, but you people have to look for it very fast before it's become to late for her operation.

Then Phillip ask him while Jessica was still trying to wake her mother up, by shaking her on the bed and by still bringing tears from her eyes.

Phillip
Okay sir, when do you need such type of amount before it's become so late for us?

Doctor
Tomorrow it will be good.

Amber
And if we can't bring it tomorrow, what are we suppose to do doctor?

Doctor began to go out by saying.

Doctor
I give you 1 week to bring that amount right here, and if you guys doesn't bring it, then, watch your mother turn mad.

Then, when he finally reach outside, Phillip seated on the floor crying and finally ask Amber.

Phillip
One week? Who does he think we are?

Amber knee down, trying to calm him down and ask him.

Amber
What if you call your dad and tell him what is really going on?

Phillip
I call him before, but he didn't pick up my call.

Amber
Why?

Phillip
Don't know.

Amber
Don't you think something happen to him too?

Phillip
No!

Amber
Then try again to call him, try back.

Phillip
Okay!

Then Phillip took up his phone, and dial his dad number, and put it on his ear, then, the phone began to ring, and his dad was still sleeping on the bar table, the phone rang for 2 minutes, then Phillip turn it off and look at Amber, who said to him.

Amber
Try again. I'm sure he will answer this time.

And Phillip dial back the number of his dad, and try to call him back, while, Amber phone ring, and she remove it from her short trouser she was wearing and answer to the phone who was angel, and their conversation was this.

Amber (Phone)
Hello!

Angel (Phone)
But where are you guys?

Amber (phone)
Hospital.

Angel (phone)
Hospital? What happen? Are you both okay?

Amber (Phone)
Yeah! We are fine.

Angel (phone)
What are you both doing inside the hospital at this time of the hour, while school hasn't yet finished?

Amber (Phone)
I'll let you know later on, but what is it? Why are you calling me now?

Angel (Phone)
As you can see, the have just gave us our mathematic result.

Amber became a little bit proud by asking back.

Amber (Phone)
Really? How many A does the class has?

Angel (Phone)
Aw Aw, bad news, only Phillip and Organ has the best mark.

Amber look at Phillip who wasn't on his phone any more but looking at her, while she was asking to angel by smiling a bit to Phillip.

Amber (Phone)
Are you serious? Even you haven't had any good mark?

Immediately, Phillip who listen to her talking about marks, stood up from the floor by wiping his tears and asking to Amber when she was still on the phone.

Phillip
What?

Angel (Phone)
Yeah! When I told you only Phillip and Organ, you have to believe me.

Amber (Phone)
Oh my God, what are we suppose to do now?

Angel (Phone)
Don't know, okay, I have to go, see ya!

Amber speak louder on the phone while it was going off.

Amber (Phone)
But wait!

Phone off, and she look at Philip who was asking

Phillip
Who was that?

Amber
Angel

Phillip
So what were you both really talking about?

Amber look at him face to face and they both seated on the floor, while Phillip took Jessica, and put her in front of him and Amber was explaining him this.

Amber
As you can see, they have giving us the mathematic papers already, and angel told me that, is only you and Organ who has the best mark on the paper.

Phillip
Really!

Amber shake her head by saying.

Amber
uh-huh!

Then Phillip look at her strangely and ask her.

Phillip
So what are you going to do? Will you tell that bad information to your dad?

Amber change the conversation by saying.

Amber
Let's forget about that, the person that we have to talk about now is your mother.

Then she stood up from the floor, same time, Phillip stood up too, then Amber said to him. (Let's go out side, and talk about that). Then, while going out, they finally reach, and they went and seated on top of Amber car, while Jessica was seated on the back and inside the car, then Phillip said.

Phillip
What if you call your dad and plead him to give you back your credit card?

Amber look at him and said.

Amber
What? Your not serious Phillip, how can I ask such things to my dad when the result of our mathematics papers just came out? And specially with that bad result, do you think my dad will ask the principal to release back my credit card? Uh huh, no way boy, no way, I wouldn't try such things.

Then, Amber turn and finally put her legs inside her car, and she look at Jessica sleeping and she say to herself. (Aw…. Poor girl). Then immediately, look at Phillip and told him. (Hey! What if we should go into Chinese restaurant and eat?). And Phillip reply back to her.

Phillip
Chinese restaurant? What for?

Amber
But don't you see, your sister hasn't eating anything this morning?

And Phillip said to her.

Phillip
Are you sure of what your talking about? Cause we was suppose to go back to school and pick up our mathematics result.

Amber
Please, forget about that, angel will bring it to us, oh wait!

She remove her phone from her small trouser she was wearing, and dial angel number, then send the call, and put on the phone over her ears and the phone began to ring, then angel pick up and answer to her.

Angel (Phone)
Hello!

Amber (Phone)
Hey! Is still me angel; please is it possible if you can ask to the mathematic teacher to give you my papers?

Phillip shouted behind Amber back and reply.

Phillip
Hey! Do not forget about me

And Amber directly smile by saying to angel.
Amber (Phone)
Oh! Even Phillip papers too, can you? Please?

Angel (Phone)
I can't promise anything, but I will try.

Amber (Phone)
Thanks Dear.

Then, off her phone, and said to Phillip. (Can we go now?). Phillip smile back to her and reply.

Phillip
Why not, we can.

Then Amber, start on her car, and she drive the car, and they left. While the other side of Mr. August Johnson, who was still having his head on the table of the bar sleeping, directly, the barman came near him and said to him.

Barman
Sir! You haven't paid me anything yet, so wake up.

And he didn't wake up, until the barman shake him by still saying. (Sir! Wake up and pay me what your owning me). While he was shaking Mr. August and touching him on the shoulder, August, open up his eyes, and look at the barman by asking him.

August
What?

Barman
I need my money.

August began to stand up slowly in the same way like a drunk man, and by asking to the barman.

August
Your money? Which money are you talking about? Cause I don't owe you anything.

Barman
Of course you own me money from what you just took with out paying.

Then Mr. August remember and said to him.

August

Oh!!! You mean, what I have just drink right now?

Barman

Not now, but yes.

Then, August remove some amount of money into his pocket and ask to him

August

Hm.. So how much is it? How much do I owe you?

By showing $10 to the barman who look at it and reply back to him directly.

Barman

This isn't what you owe me sir.

August

Then how much does I owe you?

Barman

$15.

August

What? $15 for how many bottles alcohol did I took?

The barman began counting those bottles of alcohol August took.

Barman

One, two, tree……

And immediately, August stop him counting by saying.

August

Wait, wait wait wait, its okay.

Then, remove back, five dollars from his pocket, and add it to the ten dollars he gave to the barman by saying. (Here is it). Then, the bar took it by answering back.

Barman
Thanks sir.

And began to peak those empty bottles on the table, while August was going out and shouting to those who was still inside the bar that.

August
Thanks everyone for your understanding.

Then continue working as a drunk man, while the other side, Phillip, Amber, Jessica, was already inside the restaurant, waiting that they should come up with the book that has all the name of good foods, Chinese and Americans food, so when they was inside, Philip was looking at the beautiful of that restaurant, then ask Amber.

Phillip
Amber, how much does one plate of food can cost here?

Amber look at him curiously and reply back.

Amber
Only six dollars.

Phillip became so surprise and ask her.

Phillip
Six dollars? And you think it isn't to much for us to use such amount to pay for my mother operation?

Amber
Your mother operation? Phillip. Your mother operation isn't eighteen dollars but $80, so?

Phillip
But we can still keep that amount, and then work each others to add to the one we have.

Amber
Hmmm...

Phillip
Besides, do you have such amount right here?

Amber
Yes, I have it.

Then Phillip shows her his hands and ask her.

Phillip
Can I have it?

Amber
No....! What for?

And Phillip finally stood up, went and carried his sister on his shoulder by saying to Amber.

Phillip
I wouldn't seat right here, and eat such amount, while my mother is into the hospital dying of pathologies.

Then began to work out while Amber shouted by standing up from her chair and running towards him, at that same time, the person who was suppose to come and ask them what the have to eat, reach near their chair and shouted to them, that (But are you guys, aren't eating any more?). That same time she

was shouting like that, Amber was also shouting to Phillip and saying to him.

Amber
But your dad can afford such type of amount Phillip.

She went into her car, then, start on the car by driving slowly, and by following Phillip on the back, by talking to Phillip and trying to convince him. (Please, Get inside. Come on). Phillip who wasn't looking at her, but still carried his sister answer back to her.

Phillip
No, I wouldn't; until you change your mind on what you was suppose to do.

Amber
But I have change my mind already Phillip, please come inside the car.

Phillip
No and no and no.

Amber
Okay, tell me, how much to do you have to pay up a taxi for you and your sister?

Her sister who was already up was just looking at Amber while Phillip was replying back to Amber.

Phillip
We don't have to pay anything before reaching at home; we both have legs that God gave it to us.

Amber
Please, don't be so stupid Phillip, cause for sure, you cant work that way with your sister when sooner,

the night is coming on our way, so enter into the car now, come inside.

Phillip
Nope! I wouldn't, even if you force me too.

Amber
Okay, you was right about everything, I will give the amount to you, so that we should work together on something that will help us win much amount of money to add on this one and then give it to the doctor for your mother operation.

Phillip directly became happy and answers her back.

Phillip
Are you serious? Or you're saying this for me to get in?

Amber
No, I'm serious, okay, wait!

Then she off the car, remove the money inside her purse and immediately show it to Phillip by saying. (Here is the money, have it). Then Phillip looks at her, smile and said to her by getting inside the car.

Phillip
No thanks. I suggest you to keep it, when the right time comes for us to add on the one we have work on, then we will just add it as simple as that.

While he was finally inside the car until the closed the door of the car, Amber asks him.

Amber
What do you think if we should go into my house and I ask Rita to cook us a delicious food?

Phillip
Yeah!!! That's the right idea you were supposed to ask that to me since.

Then, she directly drive her car fast, and Phillip who was seated by caring his sister shouted and holding her stronger that. (No.............). On the other side of August home, August reach at his house, and directly, he try to open up his house, but it was lock, then he ask to him self.

August
But, where have they gone too?

Then went and stand in front of the window of the kitchen, by looking inside, and began to speak louder. (Jessica. Jane. Is there any body home? HELLO!!!). Then decided to go in front of where he was, then put his hands inside his pocket, remove the 2nd key from there, and open up the door, then, went in, and lock the door back, and began to went up stairs through his room, when he got there, he felt on his bed, and began to sleep and sleep and sleep, until yawning.

On the other hand, Organ was with his friends his house, thinking on how they will know Phillip secret, how he did to become very intelligent after one week just like that, while thinking, Organ mother knock on Organ's door. A woman of 50 years old who dress well.

Organ
Who's that? Come in.
Then, his mother came in, look at him and directly Organ asks her by shouting to her. (Mom, what the fuck did you came here to do?). His mother became scared at his question said to him.

Mother
I'm so sorry my little pink; I just came here to
find out if any was alright for you guys

*Organ who was still angry against his mother said
to her.*

Organ
As you can see, we are find mom.

*So stood up from his chair, went and hold the door
that wasn't yet closed and said to his mother. (Mom…..)
She turn look at him and he said to her. (Can you bring
those your ass, out from my room right now?). And his
mother smile at him, and she left him, then he closed
the door of his room back and said to his friends by
going back and seated on his bed, while they tree of
them was still standing up, and the was putting their
back on the wall. (Guys, we seriously have to find
away what made Phillip so intelligent this days). His
friend Nick jump and sat on Organ table.*

Nick
Your right Organ, but how are we suppose to do that?

*Organ look at him strangely and began to think and
said to him.*

Organ
Hmm…, well, what if we should try to be his friend,
and try out to ask him anything about his secret?

Chris said to Organ.

Chris
For god sake, that wouldn't work at all, because
he's not stupid.

And Clack said.

Clack

I support you Chris, it wouldn't work, if only, one
of us should leave our unity, and attach his self
over Phillip, I think that will be a good way for
us to know his secret.

Organ began to look at them curiously and ask them.

Organ

So who will be the person?

*And he began to look at them one by one by saying.
(Is it going to be you nick? Or Chris? Clack what
if it is you?). Clack look at them and he answer to
Organ.*

Clack

Not me for God sake.

*Then, nick put up his hand with scared and said to
them.*

Nick

I think I will try.

*Then Organ smile at him, stood up from his bed and
said to Nick.*

Organ

Yes, I think you'll be the best person to be his
closed friend and give us all the information we
want.

Nick

Okay guys!

*Then, they finally smile back again, while Phillip
was already on the carped with Amber(into Amber*

house); playing with food, Phillip was throwing the food up, for Amber to catch it with her mouth, but it was falling on the floor, then, Amber send it up too, and Phillip catch it, and they both did it many times by smiling, while Jessica was on her own table eating already, after playing each others, until the was tired, Phillip fall on the carped by resting while Amber slept on his stomach, and she ask to Phillip.

Amber
Phillip

Phillip
Yes!

Amber
Where will you be going to spend your holidays?

Phillip
Don't know, maybe, Miami, Vegas, or why not Paris, who knows?

Amber
As for me, I'll go and meet my mom in London.

Phillip
In London? Does your mother live there?

Amber
Yes, she's there with my younger brother Luscious.

Phillip
Your younger brother? But I didn't know you was having a younger brother, very interesting.

Amber
Why?

Phillip
Because, he can be my younger sister lover.

Amber stood up from his stomach by knocking him on his shoulder and saying to him.

Amber
Damn Phillip, your own behavior is really strange this time, was wrong with you dude?

And Phillip stood up too, by laughing out loud and by holding her into his arms and bringing her down to the floor, then, try to sleep on herby kissing her, while, directly, his younger sister approached near him and when he was wanted to kiss Amber, his sister directly say to him.

Jessica
Phillip, please I want to go back home to meet dad.

Then, Phillip stood up from Amber, and he looks at his sister and said to her.

Phillip
Oh! Your right Amber, I think we have to go.

Then Amber stood up too, and took up her car keys who was on the table, by following them outside the house, the other side, of August who was still sleeping, directly, five parents with their children's who are student with Phillip, came, and they ring August home bell, and August who listen to that; directly jump up from his bed, and came down stairs the house by going to the door and shouting all over and saying to those who was behind his door that.

August
I'm coming.

*Then, when he finally reach there, he open up his
door, firstly saw it was late (dark outside), then
before he saw some old people who was standing
there, and he ask them. (What can I do for you?).
And one of those parents who was and old woman
reply back.*

Woman
We are looking for Phillip Johnson and his parents.

August
May I ask why?

A different woman directly reply.

Woman 2
*As you can see, this are Phillip classmate, and
since your son came into the same school our
children's are, he turn them all to look so stupid.
Then, one man between those parents, remove his son
mathematic paper, and show it to August, and August
saw that the was a bad result on it, while that man
show the paper; he directly said to August.*

Man
Look! This prob happen because of your son, okay!
Because of him.

*Then, by making his face to look angry, directly,
August move on for them to come in by telling them
at the same time.*

August
Oh! But come in please.

*Then, they came in, and he show them the place
where they could be seated by telling them. (You
may have a seat). Then, the went and seated on the*

same place, and August seated on his own place and said to them, and by even crossing his legs. (So, as you guys just told me all this, I promise you, when he will be back, I'll deal up with him first, before, you guys should do what so ever you want to him). And they all agreed by saying.

Parents
Okay!

Then, August ask them by standing up and by getting into the kitchen.

August
So what should I offer you?

Those parents look at them each others before answering to August.

Parents
Tea, only tea.

Then, August went into the kitchen and began to make them some cup of tea, and while doing it, Amber car just arrived in front of the door, then, Phillip ump out from the car, while his dad, who was inside the kitchen look through his kitchen window, and saw them and said to himself.

August
Oh! Finally, here is him.

Then, Phillip carried his sister, and said to Amber.

Phillip
I'll call you

Amber answers while going.

Amber
Okay!

Then, they began to go inside the house, and August came out with those tea, then gave it to those parents, and Phillip who was coming inside the house, saw the light inside his house, and look on the left of the house, saw a big stick, then peak it, and put his sister on the floor and began to try going inside, when he was wanted to open up the door, his father who finally reach near the door, open it for him, and Phillip look at his dad face to face, and his dad look at him too; then, Phillip smile, and his dad shift a bit for him to come inside; while Phillip was coming inside, his dad look at Jessica, then, carried her, by saying.

August
Aw…. here you are babe.

Then, went inside, while Phillip look at those parents, and some of his classmates, he looks at them curiously, and smile by looking at them by following his dad slowly into the kitchen, when his dad was inside the kitchen already, his dad took one cup, and make Jessica tea too, and gave to her, then Phillip finally reach inside the kitchen and directly ask his dad.

Phillip
But Dad, what are those people doing here?

His dad looks at him with an angry face and asks him with anger.

August
For God sake, where have you been with my daughter?

Phillip was wanted to explained to his dad directly, while his father immediately box Phillip on the face by continue shouting to him and pointing his finger to Phillip while Phillip was already crying and was pleading his dad.

Phillip
Please dad, let me explained

August
Explained what? Huh? Tell me boy, what do you want to explain to me?

Phillip still crying answer back.

Phillip
But everything dad, everything.

August
I don't want you to explain to me anything; you think your mother will be here this night to support you again? Cause the other day you find yourself into prison, while coming back home, resting, and read your book after, but you haven't done that, but you took your fucking time, going outside and steal people money, to find your self later on in jail, and you think, that, this time again I will still forgive you for your fucking mistake? Huh?

And Phillip shouted to him by replying back.

Phillip
But dad, please, let me explained to you, please.

His father began to go up stairs, while when Phillip shouted his last words, those parents and Phillip classmate who was into the living room, listen to Phillip voice, stood up and try to work little by

146

little through the kitchen by pointing their ears toward the kitchen, and August was saying to Phillip.

August
You don't have to explain anything to me, wait for me there, let me come.

When they both was discussing, Jessica was crying, and directly, when August finally reach inside the living room, he saw those people, and those people stood up straight, by looking at August and smiling, then, August directly started working on the stairs of the house by going inside his room to pick up a big wood to come and beat Phillip with it, then, Phillip stood up directly when his dad was already inside his room, and Phillip ran away from the kitchen by going out, and by pushing those parents down who was blocking his way and his classmate who was already going out too, then, when Phillip reach outside, he, remove his phone from his pocket, same time, use his t-shirt to wipe the blood who was coming out from his noses, and by dialing Amber number, when she answer back, he said by bringing tears from his eyes.

Phillip (Phone)
Amber, please, I need you here.

Amber (Phone)
At your place?

Phillip (Phone)
Yes.

Amber (Phone)
Is there anything going wrong with you?

Phillip (Phone)
Yep!

Amber (Phone)
Okay! Wait for me outside, I'm coming.

Phillip (Phone)
I'm already out, but not far away from the house.

Amber (Phone)
Okay Phillip, I'm coming.

Then, Phillip off the phone, while August reach inside the house, and he saw that there wasn't anyone into the living room any more, and he went back inside the kitchen, and watch his daughter who was still crying her eyes out so he then carried her.

August
Its okay Jessica, stop crying love, stop crying baby, please, stop crying for your dad sake, please…

Then, took his phone, and dial his wife number many times and many times during six minutes, and no one answer the call, then he put it on the table of the kitchen and ask to him self. (But what the hell is going wrong inside this house?). On the other hand, Phillip was walking when Amber reach beside him, and stop the car, then, look at Phillip and said.

Amber
Come on, get in.

And Phillip jump inside, then she smile and she look at Phillip face and ask him. (But what happen to your face? Did you had a fight with any one?).

Phillip
No

Look at Phillip curiously and said.

Amber

Hmmm... I'm sure; Organ is the person behind all this.

Phillip

No! it isn't him, but my dad.

Amber

Your dad? What for? Has he accused you of your mother sickness?

Phillip

No! He hasn't. Please, I don't want to talk about this anymore, please bring me somewhere else.

Amber

Some where else? Hmm.... I know one place that you will seriously love it, let's go.

Then, start on the car, and drive it very fast, to the place she was talking about, until the reach in a little place looking like Las Vegas, where they was night clubs, cabaret, a lot of funny games, so when they reach there, Phillip looks at young, and old girls dressing half way naked, some people having different types of colored and Phillip ask Amber.

Phillip

Where are we?

Amber

This place is the city of harmony and where you can win a lot of money if you use seriously your mentality.

Phillip

Hmmm.... Interesting. So how does it work?

Amber
Simple, look at all the places, and tell me which
one can you play to gain money?

Phillip began to look at those pleases, saw some
white and black boys dressing also half naked with
a lot of abs on their stomach, and who are trying
to get inside the club to dance for rich women's to
gain money, so Phillip stood up into Amber car, and
remove his t-shirt, and then show his own abs to
her by saying to Amber who was still driving slowly
for Phillip to look at places over there, so when
Phillip was showing his own abs to her by saying.

Phillip
What if I show you mine too?

Amber began to laugh out loud and say to Phillip.

Amber
Come on; put back your clothes down.

By holding Phillip clothes by putting it down, when
Phillip was seated back on his chair, directly after
sitting back by smiling, he saw some young boys and
girls of over 22 to 35 years old getting inside a
big room by giving money to the controller who was
also the guardian of that place, then Phillip ask
Amber this question.

Phillip
Amber; what is seriously going wrong inside that
room?

Amber look at the room and she reply back.

Amber
Oh! That room is for university's people, those that
can answer greatest questions.

Phillip directly asks her.

Phillip
Greatest questions like mathematics, history, physiques or is it questions about sexuality?

Amber
Sexuality? Don't know, but the others you just named like, history or physique, that one I think, yes.

Phillip
So is it a game to gain money or something just to play for nothing?

Then Amber stops driving and answer back to him.

Amber
Let me tell you some few details. As you can see, this game its only made for brilliant people as I always said to you, like, when you get inside there by giving your own amount of money, two of those who sign after they you, will first play against each others, then the person who will win the other guy, will the take the money of the guy and then, add it into his other amount he has given there for it to be kept, and end; we left with the money.

Phillip was very surprise about that, and then asks curiously to Amber

Phillip
Hmm… interesting, so, how much can I put to play the game?

Amber
Wait a minute; don't tell me your interest to play that game?

Phillip
Of course I am.

Amber
But you're not so intelligent.

Phillip removes his glasses from his T-shirt and shows it to Amber by answering to her and smiling.

Phillip
Have you forgotten that my glasses will help me for that?

Amber point her finger to him by smiling and saying.

Amber
Hmmm….. You have the right idea Phillip, and I think, we'll make it.

Then, she kept her car where others was keeping theirs car too, and then, Phillip jump outside from the car, and, Amber upon up the car, and she came out too, then, upon her tool box from. her car, remove two cap, (yellow and blue) who was inside, and while Phillip was trying to go where that game was wanted to take place, she stop Phillip by saying. (Wait!). And Phillip turns back, look at her and smile, then ask her.

Phillip
Don't tell me that we are going to use those things by getting inside there?

Then, she looks back on those caps strangely and she asks to Phillip by smiling and approaching toward him.

Amber
What's wrong to with that?

When Phillip was speaking by saying.

Phillip
Nothing, it will just look funny, that's all.

Then, she put the cap on Phillip head, and smile back at Phillip, by also fixing the cap on his head the way he will look like a real boy of the Las Vegas night club (gangs man); then, she hold his hand, and they both began to work toward that room, when they was already reaching there, Amber stop working look at Phillip who immediately ask her. (What's wrong?).

Amber
I think we have to go back and look for something else.

Phillip
Why?

Amber
Because, we only have eighteen dollars with us, and to get in there.

Immediately Phillip finished Amber word by saying.

Phillip
You need more than eighteen dollars to play it, right?

Amber
Yep!

Then Phillip told her.

Phillip
But, that isn't the prob, let me handle it for you my queen.

Then, hold Amber hand, and went with her in front of that place, and look at the bodyguard who was there taking money and put it inside a machine, and who was sending the money to some one inside, then, they bodyguard, look at Phillip curiously for fifteen seconds, then, started laughing at Phillip out loud.

Bodyguards
Ha ha ha ha ha ha ah aha….

Phillip and Amber look at the man in a funny and stupid way, before Phillip ask to Amber.

Phillip
What's wrong with the man?

Amber
Don't know.

Then, when the man finished laughing out loud, he asks to they both.

Bodyguard
Tell me, which one of you want to get inside there and play the game?

Amber and Phillip point each other by answering to the man.

Phillip and Amber
Her, him.

At the same time, and they man look at them very funny, and began to smile back louder.

Bodyguard
Ha ha ha ha ha ha ha ha ha

While a young boy looks like 24 years old, passing his way and look at Amber sexier, and say to her.

Boy
Woo…; so sexy

Then, beat Amber ass, while Phillip look at the guy and shout to him when he was already inside that.

Phillip
Hey! She's mine.

Then, the man stop laughing louder, and show up his hand to them, then asks them.

Bodyguard
How much do you both have?

Amber remove the eighteen dollars, and show it to the man by saying.

Amber
Eighteen.

The man looks at her strangely and said.

Bodyguards
No no, eighteen will not be good for you both.

And Phillip reply fast.

Phillip
No. For real, I'm the one who will play the game, not her.

The man looks at Phillip in a funny way and asks him.

Bodyguard
Sorry! You? Not her?. Oh my gosh. Oh my gosh…. Ha ha hah ahahaha.

And Phillip ask back Amber.

Phillip
But what's wrong with this guy? Is he losing his senses?

Amber
Don't know!

Then, the man stop laughing and said to them.

Bodyguard
Firstly dude, don't you see your so young to play such type of game? Secondly, those people inside there will eat all your money, and do you know why?

Said this word in a funny way before laughing at Phillip. (Because, those questions they are asking inside there isn't for kid's boy… ha ha ha ha ha). Then Amber stop him laughing by immediately saying to him.

Amber
Wait! Wait! Wait! Wait!…..; tell us the prize and we are going to show you that, the appearance isn't what make a man, but what is coming out from a man.

Then, they man stop laughing and said.
Bodyguards
Huh? Are you serious you guys really want to do that?

Phillip
Yes, we are.

Then look at them curiously by answering back.

Bodyguard
Okay! The amount for the game is thirty two dollars.

Phillip shouted by looking at Amber at the same time asking the both.

Phillip
What? Thirty two dollars? For God sake sir, where are we going to take such type of amount?

Then, the man approached him self near to them, while they both was so scared by going back a little away from the bodyguard, and he hold them on their shoulders and reply.

Bodyguard
I'm able to give you such type of amount, if only you guys promise me one thing.

They both answer back at the same time.

Phillip and Amber
Like what?

By looking at the man into his eyes and saying the man answer.

Bodyguard
If I give you such amount, and you failed it, then, you both will come inside my house this night, and help me watch all the house, likes plates, floor, kitchen, tables, TV…..Immediately, Phillip cut down his word by saying.

Phillip
Even your dresses, we will clean it up.

And the man said.

Bodyguard
Yea! You will, so, do you both agreed the contract?

And Phillip greeted him, by saying.

Phillip
Yes. We agreed.

Bodyguard
Good.

And greeted Amber too. Then, the man remove a big amount of money like more than nineteen thousands dollars, and began to count it, while Phillip look at it and said to him self.

Phillip
Woo…………

And directly Amber asks to the man.

Amber
But if we win it, what we will gain?

Phillip
Good question Amber.

And the man who was counting such big of amount of money, stop counting by having all the thirty two dollars into his hands and answer to them.

Bodyguards
If you both win it, then, the money wouldn't come back to me any more, and plus that, I'll add you guys thirty dollars, means, the guy who also gave his thirty two dollars, will give me thirty dollars, and I'll twenty eight dollars to you guys.

Phillip

No! not twenty eight, but thirty dollars as you said.

Amber looks directly to Phillip and ask him.

Amber

What?

Then, Phillip hold her hand immediately, and move a little bit away form the bodyguard and said to her.

Phillip

Have you forgotten that, thirty two plus thirty plus eighteen equals to eighty?

And Amber directly turns back by looking at the man and saying.

Amber

Aw…….. okay!

Then, they both started going inside, and when they both arrived near the bodyguard, the man show them the money, and Amber took it, then, both went in, while working inside the place, the millions of those who was seated there, began to look at them strangely, while Phillip was looking at those who was answering those strong questions, then, one of those bodyguard s who was inside that same room with them, saw them working and hold their two arms and ask them.

Bodyguard 2

Where are you both going too? Have you already paid?

Then, they both was scared, and Amber show up the money to the man, by showing also the man a funny scaring face, and the man look at the money, and

said. (Good, so between the two of you, who want to play?). And Amber point at Phillip by answering to the man at the same time.

Amber
Him sir.

Then, the man left their clothes, and said to Phillip.

Bodyguard
Okay, you may go and sit behind those people dressing on white, and do not forget to pick up your own t-shirt there.

Phillip
Okay sir.

While Phillip was going, the same bodyguard hold back Amber through her shoulder while she was trying to follow Phillip, and he ask her.

Bodyguard 2
Hey! Where are you going too?

And she reply back to him with scared and a funny way.

Amber
Don't remember.

Then the man said to her.

Bodyguard 2
Well, your place doesn't have to be there, but with those others seating there.

By pointing his fingers toward the public own part, and she began to go there and watch, and that is how

Phillip and Amber was listen to those young people answering those questions, normally, and people was applause and shouting and laughing for answers giving by university's people, and those who was questioning was 2 old people, a woman, and a man, and the room was very hug, big and tall. So, while watching on the game, the other side was August, who was trying to make his daughter sleeping, and August ask his daughter again.

August
So babe, don't you know where your mother went too?

Jessica reply back slowly with a little voice by yawning.

Jessica
Mom is in the hospital dying….dad.

August became so shock and asks his daughter immediately.

August
Hospital? What for? I mean, what happen to mom?

Jessica
Ask Phillip.

August
But, why is that Phillip didn't tell me the first time he enters into the house?

Jessica still yawning by answering his dad.

Jessica
That's what he wanted to tell you dad, but you didn't listen to him. Instead, you keep on beating him.

Immediately, his dad carries her.

August

You know what? I think I have to bring you to the neighbors.

Then began to ran outside the room, and reach inside the living room, then, pick up his car keys who was on the table, and began to ran outside the house, and by locking the door of his house, by going toward his neighbor home, when he reach there, he began to knock at his neighbor door by screaming her name and saying. (Mrs. Vanessa, Mrs. Vanessaa…). And she on the light of her living room came out from the house, and open the door of her house and saw August.

Vanessa

Don't tell me you lost your wife?

August

No! I haven't, Oh!!! So you knew it too?

Vanessa look at him strangely cause of that question and she said.

Vanessa

Knew what too? That your wife is dead or she's dying into the hospital?

August immediately put Jessica down, near her and said.

August

No, she isn't dead already. But please, is it possible if I should left you with my daughter?

And Vanessa took her in by saying.

Vanessa

Why not!

August

Oh! Thanks a lot.

By running toward his car Vanessa speak to him louder that.

Vanessa

Please, let me know about everything.

And he speak louder by answering.

August

Okay! I will.

Then, enter inside the car, start the car, and began to drive toward the hospital, while Vanessa was locking the door of her house. The other side, it was already Phillip part to come and answer his own part of question, when the light who is selecting people approached on Phillip, Phillip stood up, and cane and seated in front of the table where he will be answering the question, and he remove the glasses from the white t-shirt he was having on his eyes, then he wear it on his eyes and ask to himself before the should ask him any question, so when he finished asking the glasses came on, and he still did everything until the glasses was finally on, and the first questioner ask Phillip name, by saying.

Questioner

Hello sir!

Phillip

Hello!

Questioner

What is your full name sir?

Phillip
Phillip bleu Johnson.

Questioner
Okay, are you ready to answer the first question?

Phillip
Yes sir, I am ready!

Questioner
So what is the full name of the 16th president of the united state of America and what he married? If yes, what was his wife name?
Phillip directly ask the question to himself through the glasses, and he was having the answer and he told the questioner, and they waited for five seconds before the questioner reply. (Good answer). And every one began to applause, even Amber who was so excited and happy, and that's how the ask Phillip and the other man sited on Phillip side, and he was failing some answers while Phillip wasn't failing anything, and Amber was so excited and happy.

Then August, who reach inside the hospital very fast by running, finally reach in front of that same funny lady who was disturbing Phillip and Amber to give them the number of Jane room, so when August reach near her, he ask her while she was typing on the computer.

August
Hello! Please madam, may I have Mrs. Jane Johnson number room.

And the woman accepted.

Lady
What you want from her?

August

What? I am her husband for God sake. Damn.

Lady

Oh! Okay, wait a minute sir

Then, she look for the number of Mrs. Jane room, then said it to him and by pointing her finger where the room is situated, directly, he rushed inside his wife room, and when he came in with out locking the door back, he directly saw his wife who was still sleeping on the bed, then he knee down on the floor near her by asking.

August

But what happen to you? What's wrong darling, please talk to me baby, talk to me babe.

The same doctor who spoke to Phillip and Amber about the prize of her operation, was passing to check a different room, saw August on the floor crying a bit, then, he came inside the room, and when August listen him coming, he turn back, and look at the doctor, stood up directly from the floor and said to the doctor. (Thank God you're here doctor).

Doctor

Um.. Sorry If I may ask, is she your wife?

August

Yes, she is Doctor.

Doctor

As you can see, some children's was just here in the afternoon, and I told them something that I will say it to you right now.

August

What exactly doctor?

Doctor
As you can see, your wife is suffering from a seriously disease call pathologies, and it's a serious disease that always affect people mentality over 35 to the end of their life's, and that disease always turn some people to be mad, or some of them lost their senses, so, if we doesn't operate her very fast, she will become one of them sooner.

August became so shock and asks the doctor.

August
You said and operation? God. Okay! So how much will it cost me?

Doctor
Eighty dollars.

August
Eighty dollars? Oh my God, doctor, as you can see, they have just send me out from my job side, means I was just fired through my director general, so please, is there not any other way for me to pay you? Like reduce the amount into two; doctor. Doctor began to go out by living him there and saying.

Doctor
No sir, there isn't any other way, and if you want to watch your wife dying, then, watch her dying.

And lock Jane room. And August seated on the floor, by holding his wife hand, and looking at her, and kissing her hands, and continue by bringing tears, while the other side, Phillip finished the game, and came out with Amber by laughing out loud like.

Phillip and Amber
Ha ha ha ha ha

And by pushing them self, and when they both reach in front of the bodyguard, Phillip said to him.

Phillip
So can we have the money?

The bodyguard remove it from his same pocket and count it back, then, gave it to Phillip, and Amber show up her hand empty, and the bodyguard ask her.

Bodyguard
What?

Amber
The twenty eight dollars you was talking about, where is it?

And he makes a sign by asking them to come closer and said to them.

Bodyguard
Guys, sorry, normally, I should be given you both sixteen dollars, not thirty two, oops.

Then they both directly went back, while Amber was saying to him.

Amber
What?

At that same time, Phillip said to the guy.

Phillip
You cheater.

And the bodyguard makes them to understand him very well.

Bodyguard
I'm sorry guys! As for me, I thought you guys wasn't serious at all, that's why I also wanted to play with you both by saying all that, normally, the game is like this, you give sixteen dollars, and the other one give also sixteen dollars, and the person the fail the game, his sixteen dollars will be added into the other guy money, and the result will turn to thirty two, so, I'm sorry. Then Amber replies back.

Amber
Hmmm.. That's all we were wanted to know.

By going, then, they man call them back, by saying.

Bodyguard
Hey! Come back, and I'll tell you how you guys are going to win thirty dollars.

Then, they both stop working at the same time, and they both look to them self face to face, before the returning back to the bodyguard, and when they both was near him, Phillip ask him. Phillip Are you serious?

Bodyguard
Yes I am.

Phillip
So how are we going to have such amount?

Bodyguard
If only you guys tell me what you'll do with sixty dollars.

Then Phillip looks at Amber curiously and she told Phillip.

Amber
What? But tell him.

And Phillip looks at the bodyguard and said.

Phillip
Okay! The biggest prob we are having and why we need such amount of money is because, we need it for my mother operation, and the doctor ask us to bring eighty dollars, and if we doesn't, she may turn mad or she can die, so, that thirty dollars your talking about may help us.

Bodyguard
Means, if you guys really win that thirty dollars plus the thirty two dollars you have just win from the game, and plus the eighteen dollars you still have there with you, it will finally equal to eighty?

Amber
Yeah! You got us.

Then the bodyguard approached near them and asks them again.

Bodyguard
Between the both of you, who can do break dance?

Phillip and Amber look at them self, and directly said each other at the same time.

Phillip and Amber
Me!

Then the bodyguard went behind them a bit and said.

Bodyguard
What a coincidence, okay, as you can see, on your left while going out from this street, you'll see

a house writing on it 'street palace life" right there, there are some young guys and young boys that will sooner start a competition and that will be on live on MTV, and the winner of it will win thirty dollars as I was saying earlier.

Phillip turn back by running while Amber was follow him back, and the same body guardspeaks louder to them by saying. (The competitions begin during two minutes). Then Phillip shouted.

Phillip
Okay, we got you.

Then jump inside Amber car, and Amber get into it too, and she start the car on, and they began to go to that place quietly, then, reach there, and Phillip came out from the car by jumping outside, and by asking to Amber. (Is that place?). Amber who was going out from her confirms it to him by saying back.

Amber
Yes, it's the place.

Then Phillip went in front of the door, and a bodyguard looks at him and asks him.

Bodyguard 3
Sir, may I see your ticket?

Amber reach near him, and because she was half naked, she hold Phillip hand and said to that man standing there.

Amber
Its okay, he's with me.

Then, that man gave them the way to get in, and when Phillip reach in, he saw how people was standing

in one place to look at the dance, then, Amber went with Phillip to meet the jury, when they reach near the jury (between the four jury there was one woman); one of those jury who was seriously fat, put down his glasses and he look at Amber who was dressing very sexier and he shouted by saying.

Jury 1
Woo…. Who are my seeing here? The queen of dance crew.

Immediately, the 2nd jury asks her.

Jury 2
What can we do for you?

Jury 3
And who's that child beside you?

And Amber answers directly.

Amber
Firstly, he's not a child. Secondly, he's my man.

And immediately, the fourth jury who was a lady, laugh at her and stopping her.

Jury 4
No way! Ha ha ha, you call that a man? Damn.

Then Amber replies back.

Amber
The time you'll see him dancing, you'll look at the person your sleeping with in your house you call a man, and you will finally understand, who's really the real man here.

Then, all the others jury laugh at that fourth jury, who was already getting angry, while the first jury said to Amber by giving her the card she'll use while dancing by saying.

Jury 1
Wooooooo… you said it girl, you said it babe, you said it.. ha ha ha haha

And immediately, Amber hold Phillip hands by working toward the dance place and by shaking her waist as and Indian girl, so, when they both finally reach over that dance place, Amber put her two hands on Phillip shoulders; and she said to Phillip.

Amber
Just moved the same way I'll do.

Phillip
Okay!

Then, Amber began to dance, and dance and dance, while Phillip was also dancing, and Amber was shaking him and turning him left and right, until, it attracted people mentality over to them, and the stop look up to those others people and team dancing, then they approached them self over to Amber and Phillip, with out looking on those others people, and they even started smiling and clapping their hands and shouting all over, and that is how all the jury stood up, and check on them, while MTV base brought UP THEIR cameras to filmed them, and the secretary of the hospital where Mrs. Jane was, while that secretary was eating her pizza, directly, she turn her head toward the TV, and she look at Amber and Phillip dancing, then, she added the Volume of the TV, then began to smile, and was so excited to look at those teenagers dancing, then

she began to dance on her own chair by doing some movements during two minutes, before those who was seated on their own chair into the hospital shouted by asking her to slow down the volume, and she directly shut the TV down, before her director began to approached from her by working very fast, and when he reach near her, he ask her.

Director hospital
What the hell is going on here?

Lady
Hmmm... just a little noise coming from the TV sir.

Director hospital
Then, don't do that again.

Lady
Okay sir!

Then, the man left her. The other side of Phillip and Amber who finished dancing, directly, the first jury who was holding the amount of thirty dollars ask the public.

Jury 1
Hey guys, who should we give this amount of money? Is the stumbled light? The mentality's? The fighter warriors? The scrambles'? Or this two young soldiers?

And the public began to shout over.

Public
They soldiers, they soldiers.....

While shouting all over, Phillip and Amber began to smile, while Amber was asking to her self.

Amber
The two young soldiers???

Then, the jury 1 gave them the money, and Amber took it, then, they both began to say all over to the public

Phillip and Amber
Thank you, thank you.

By going out form that place, while MTV was trying to push the public and ask they both some questions, and those four others group name; the stumble light, The mentality's, The fighter warriors, The scrambles, was asking each other with anger that.

Groups
But what have they even done?

By asking that and trying to get into a fight into that place, at that same time, Phillip and Amber finally reach out side that place, and they both began to run over the car, when they both reach inside the car, Amber start on the car, and she drive the car towards the hospital; and the other side of Phillip dad, who was sitting on the floor, having his head on his wife hand, and still sleeping; directly, his wife began to shake up her hand and trying to wake up, and when he feel his head shaking up, he directly upon up his eyes, and look at his wife by saying to her and by wiping his tears.

August
Jane, baby, it's me, your husband, please upon your eyes for me, please baby, please.

She decided to open up her eyes, but when she was opening her eyes, she was looking at her husband

strangely, because her sights was like, black and white, the, her husband became so excited that he stood up quietly from the floor and ran toward the door of her room, then open the door, and began to shouted all over the corridor by saying. (Doctor, doctor, doctor). Then, because the doctor wasn't coming there, he then, started running all over by going to meet that same secretary by still calling the doctor, until he saw the doctor coming out from a sickness person room, by holding his mouth and asking him slowly.

Doctor
Hey! What's wrong?
August who was so excited reply back.

August
Doctor, my wife is trying to open up her eyes, please come and see it by yourself.

Then, hold the doctor hand and by running with him toward the wife room, when, they both reach there, the doctor find out that Mrs. Jane was already seated on the bed looking at them, and he show up his five fingers by asking her.

Doctor
Hmmm… how many fingers do you see?

She began to murmur and by replying back to him.

Jane
Four, six, hmm… I think five yeah! Five.

While speaking (murmuring) this way, her husband was behind the doctor trembling, cause he thought she was blind, so when she finally said five, he became so much happy, then, the doctor use his torch who was inside the pocket of his t-shirt and he upon up

the eyes of Mrs. Jane, by using the torch to look into her eyes if everything was okay with her, while asking her if she's find and she reply back. (Yes doctor, I think I'm fine). Then, the doctor turn back, and hold August on his shoulder by working toward the door with him and by saying to August slowly.

Doctor
If you doesn't do any thing to pay up that $80 for her operation, I promise you sir, she wouldn't be in health for long, so I suggest you to do your best after talking to her, by going outside there and look for the money of her operation sir.

August
Okay doctor, I got you.

Then, the doctor left him, while August went and seated near his wife who ask him, while he was kissing his wife on her skull.

Jane
Where are the children?

August smile and by replying back.

August
Hmm… Jessica is at home, while, I got into a fight with Phillip.

His wife shouted to him while he was a little scared and ashamed about his answer over to her.

Jane
What? Why such things? I told you a lot of times that Phillip isn't your younger brother for you to beat him up the way your doing.

August

I know, but the time I came back home, I thought.

Immediately, Jane stops him, by saying.

Jane

Thought what? Do you want to kill the only son we have August?

August

But no, I don't want that.

Jane

So you have stopped all those shit you're doing to him.

She began to feel pain by holding her chest and she shout a little bit. (Aye!). Immediately, August hold her hand where she was putting on her chest, and he directly ask her

August

Oh my God. Babe, are you feeling any pain? Baby.

Then wanted to stand up, by going to call back the doctor, while his wife holding him back and said to him.

Jane

Isn't by calling the doctor who will solve our problems, but only prayer can do that, so please, stay with me.

Then, he sited back on the bed, and she ask him. (So how is Jessica? And why have you not brought her here? Than living her in the house alone?).

August

I haven't left her alone in the house; I went and left her to Vanessa.

Jane

Oh, that's good.

Then August kiss her on her lips, while Phillip and Amber was coming into the hospital by running toward Jane room, and that same secretary saw them, and shouted to them.

Lady

Hey guy's; you both did a great job.

And Amber who was running with Phillip toward that same room, ask to Phillip.

Amber

Great job; Like what?

Phillip

Don't know!

Then they both finally reach in front of Jane hospital door room, when they both was there, Phillip directly open up the door very quietly, and he saw his dad seated near his mother, and he look at his dad with anger, before left the room, and his mother shout over to him by saying.

Jane

But Phillip.

While Amber look at them both strangely, and started running behind him, and by calling Phillip name.

Amber

Phillip, please wait! Please, just wait for me.

And Mrs. Jane said look at her husband and said to him.

Jane
Darling; why don't you go and solve this problem with him?

Then, directly, her husband stood up from the bed, by saying to her.
August
Okay dear!

Then, kiss her back on her skull, then left her inside, by going to meet Phillip, while Amber stop Phillip working by holding him on his shoulder while he turn look at her and she was asking him.

Amber
Phillip, it isn't by running away from your dad for the mistake he did in the past, that will finally solve the prob you both are having, so please, come back from your senses a little bit.

And directly, Phillip dad reach where they both was, and approached him self near Phillip, and he said to Amber.

August
Please, is it possible if you should let me speak to him?

And Amber looks at August and agreed by saying.

Amber
Okay Sir

Then look at Phillip and said over to him. (Please calm down; and listen to him, and you'll finally

understand the real and good reason while he was behaving that way over to you).

Phillip
Okay!

So she went into Mrs. Jane room, while August started working with Phillip toward a quiet place but from the hospital and he was saying to Phillip by working over.

August
I know I was so cruel with you, I never listen to you, never makes you happy since you were born, and I have always beat you up for no reason or for stupid's reasons. So when they reach on place that there was a big silence, he turn, look at Phillip into the eyes and they both directly seated on the long chair who was there and he continue saying. (Please son, accept my forgiveness, for us to re-start back everything I haven't make it with you when you was still a child, please). Phillip who was still angry stood up by bringing tears from his eyes and began to look at his dad who was on the chair then said to him with anger.

Phillip
Oh!!! Dad, so is it now that you remember all those fucking behavior you were doing to me? And you think it will be easy for me to forgive you this way?

His father immediately stood up from his chair and said to Phillip.

August
Yes son, its now that I am asking you for forgiveness, I didn't knew how much it was destroying your future, I didn't knew how much it was getting you

angry, I didn't knew how much it could be making you to be so selfishness….. I didn't k….

Immediately, when he was wanted to continue by also bringing tears out from his eyes too, his son said to him.

Phillip
I know that entire dad, I know you wasn't knowing your mistake, I know that dad, so how do you want me to forgive you just like that? And what for?

When he was wanted to go and meet his mother into her hospital room, his father knee down and said to him.

August
Son! My knees are on the floor for you.

Phillip turn back and look at his dad by saying with a big shame.

Phillip
Dad!

By approaching him self toward his father, and when he reaches near his dad he said. (But dad, stand up, you want people to look at us strangely as if you was my wife?). Then his father began to stand up by saying to his son.

August
I know, I did you things that a real father shouldn't be doing to his own son, the time I was capable to help you into your lesson from school, I didn't do that, I try also use you as a slave when you was still a kid, I did things to you very wrongly, and right now, I am so sorry Phillip, please open

your hearth for me, and forgive me for all the past I didn't behave as a man into the family, please forgive son.

Then, Phillip approached himself toward his dad, look at him for 8 seconds, before smile back at his dad, and by saying.

Phillip
Dad, I have forgiven you since, and a real son does not remain angry against his parents just for foolish reason, you have been forgiving dad.

When Phillip was saying all this to his father, then, he father started smile too, and then, when Phillip finished his word, he said to Phillip.

August
Are you sure son?

Phillip
Oh yeah! I am dad.

Then, they both started greeting as young boys coming form VEGAS, and by smiling, then his father put up his hand toward Phillip shoulder by going with him into Jane room, and when they reach there, open the room door, Jane and Amber who was seated near Mrs. Jane and on her bed, look at them, and smile back to them, and the mother reply to the both.

Jane
Oh oh! I think peace is now remaining into the family.

Then Phillip jumps on the bed and said to the mother.

Phillip
Mom, how are you?

Then his mother kisses him on his cheek by smiling and saying.

Jane
I am good, what about you?

Phillip
Good mom.

Jane still smiling and asking to Phillip.

Jane
Phillip

Phillip
Yes mom.

Jane
But why have you not told us since in the prison that this young and sexy girl standing near us was your girlfriend?

Phillip became shock over his mother question and said to her by smiling.

Phillip
Mom!!!

While at the same time Amber also said to Mrs. Jane.

Amber
But ma'am.

And Jane and August began to laugh at them, and the doctor came inside the room, look at them and smile and said to them.

Doctor
What a good family we have here, how's every one doing?

And they reply to the doctor.

Family and Amber
Good doctor.

Then, the doctor asks the children's.

Doctor
So guys, have you brought anything for me?

And Jane stood up from the bed, while August seated on the chair that was near the bed, and Jane approached her self from the doctor by removing the money into her pocket by saying to the doctor and showing the money.

Amber
Yes doctor, here is the amount you're waiting for.

Then, the doctor smiles more, then, took the money, and he said to her.

Doctor
That's very good.

While Mrs. Jane and August who was surprise ask the children's.

August and Jane
But where is it coming from?

Phillip reply to them.

Phillip
We wok harder for it dad.

And the doctor said back.

Doctor
So, tomorrow we are going to proceed for the operation.

And he went out with the money, while Phillip mother hold Phillip into her arms and began to kiss him every where by saying.

Jane
That's why, you're a man, I love you baby.

Phillip
Love you too mom.

Then, the next day, Phillip was sleeping on his mother and the mother back was on the wall, while Amber was sleeping on August legs, and the doctor directly came in, and he look at them sleeping, then said to them.

Doctor
Morning every one!

Then they wake up, and they look at the doctor while August reply back to the doctor.

August
Morning doctor!

Doctor
So as I was saying yesterday, today we are going to start operating Mrs. Jane, before it's too late.

August
Right now?

Doctor
Not now, any time you guys are ready, just call me.

Then, the doctor went out, and Jane hold her son hand, and call for her husband to come near her by doing it with the sign of her hand, then, call Amber too, and they both reach near her and she look at them and said.

Jane
As you can see, I'll be operating today, some times, this shit doesn't work some times, it works.

And Amber replies immediately.

Amber
Do not say that Ma'am, because when you have faith, God will always make a miracle.

Jane
Amen, but what I want to tell you guys, if it doesn't work.

Phillip and August
Stop saying that mom/ babe.

Jane
I know I don't have to say such things, but understand me first; if he doesn't work as I said, darling, please I want you to take care of our children's, no more boxing and hurting.

August
Okay dear.

Jane
Phillip, about you, please, takes good care of your dad, and your sister too.

Phillip
Mom, why are you speaking the way you'll die today?

Jane
Don't worried babe, and about you

Amber
Amber ma'am, my name is Amber.

Jane
I want you to take good care of my son no matter what happen to you both, because he's the only boy I have, and I count on you.
Amber
As you wish, I will madam.

Then, she smiles at them, then said to her husband.

Jane
Baby, please, go and call the doctor for me.

August
Okay dear.

Then, stood up, and went outside by calling the doctor and the doctor came, and ask Mrs. Jane.

Doctor
So are you ready for your operation madam?

Jane
Yes doctor.

Then, the doctor and August help Mrs. Jane to stand up from her bed, and they went with her toward the other room of operation, then, some others doctor came inside that same room too while the first doctor said to August, Phillip and Amber that.

Doctor

Just remain here and pray for her and for us too, so that we should have a positive answer in the end of the operation.

Then went back inside that room, and lock of the door, and they put Mrs. Jane on the bed, and they gave her and injection, and she slept; so August, Phillip, and Amber began to work toward the corridor round and round with scared, until that same secretary who saw them doing that say to them.

Lady

It's not by working this way that will solve all your problems, knee down and pray, that's all.

And all of them look at her strangely, until she became scared of them, and she said directly. (Oh! I was just saying). Then, Phillip, Amber, August went in front of the door of the operation room, then the hold their hands, and make a circle, then pray, and pray, and Phillip was even sweating, and fall on the chair there and slept a bit, then finally, the operation was very well make during five hours, and the doctor open the door back, and they came out by pushing Jane bed toward her room, while August, Phillip, and Amber was running behind it, and by asking the doctor if he succeeded, and he reply.

Doctor

Yes, we did it.

And they became so much happy, so when they reach with Jane inside her room, some four doctors directly carry her from that bed, and they put her on that other bed, then left, and the first doctor approach from them and he said. (I think you guys have to leave her resting a bit, meanwhile you guys have to

go out there and look for some thing to eat before one of you become sick too). Then August reply to the doctor.

August
Sorry doctor, but we have nothing here with us.

Amber
What we was having, we give it all to you sir.

The doctor removes the few amounts from the pocket of his trouser and said to them.

Doctor
Have this money, and go out there, look for something to eat.

Then, left them there, while they was also going out from Jane room by closing the door very slowly, and when they finally reach out, Phillip said to them.

Phillip
I don't want to go any where.

August
Same as me.

Amber
Okay, sir gives me that amount, for me to go out and look for something for us to eat it.

Then, August gave it to her, and she started running by going out, and while Phillip and August seated on the chair into the corridor and the both look at places, while August ask Phillip.

August
Tell me son, do you love her?

Phillip looks at his dad and asks back.

Phillip
Who? Mom?

August smile back to him and said.

August
No! I know your mother is the first person you love in this world; I'm talking about that girl.

Phillip
You mean Amber?

August
Yep!

Phillip
But dad, she's just my classmate.

August
I know she's your classmate, but the way you both are behaving together; is very different than some one can call it classmate.

Phillip
How?

August
Like, after some months you enter into that school, you always ran out from the house by saying you were going to study to a friend, while It wasn't true, right?

Phillip
Yes dad, but she's different than all those white people I have in my classroom, that's why I love her as a friend, and as a sister.

Then, his father hold him into his arms, and began to shake his hair many times and smiling by saying to him.

August
Oh o!!!...... A sister who will sooner be your wife... ha ha ha ha.

Phillip was trying to push his dad by saying and smiling too.

Phillip
No dad, that isn't true, dad stop that, stop that dad.

Amber reach there with something for them to eat, and August left Phillip head, and stood up, then went and took one of those things, by saying to them.

August
It's better if we should go outside and eat.

Then, Phillip took his own to Amber, and they all left that place by going out to eat, when they reach there, and started eating, August look at his time and saw it was already late for school, and said to

Phillip and Amber.
(Oh my God, guys, have you forgotten about school today?).

They both became so shock and Phillip ask his father.

Phillip
Dad, what's time it now?

By standing up putting the food into his mouth, while his father was answering him back.

August

8: am!

And Phillip look and Amber and said to her.

Phillip

But school always started at 7: am? Oh my God, we are late, but what about mom?

August

Just go school guys, if anything changes, then, I'll call for you.

Then Phillip and Amber started running toward the car enter, and Amber starts it on, and started driving the car, while asking to Phillip.

Amber

Phillip, what if we should go and take some shower in my house first?

Phillip

But don't you see we are late?

Amber

I know, but its better we should do that, or by getting in school smelling and watching Organ and his foolish of friends insulting us or mocking at us, don't you think so?

Phillip

Okay!

By continue driving and taking the way of her house, when they reach there, Phillip jump out form the car, and Amber said to him while he was getting in.

Amber

Are you not scared of broking those your legs one day?

Phillip
No way!

Then, went in too, and that's how, they both remove all their clothes very fast, enter into the same toilet, and began to watch them self, and Phillip was there brushing her spinal cord and she was also brushing Phillip own, then, they both kiss up there, and they both make love into that toilet, and after left the toilet, and went back, dress up, and when Phillip was wanted to wear the same dresses, she refuse by saying to him.

Amber
Have you forgotten, your clothes we bought that other day, is still here with me?

Phillip smiles at her and reply back.

Phillip
Really!

Amber
Oh yeah!

Then, she went inside her room, peak some good clothes, and she came, and gave it to Phillip for him to wear it, and he took it, and wear it, by replying back to her.

Phillip
Thank you.

Then, they went out from the house and went to school, when they reach at school, they saw angel trying to go inside the class, and they began to call her slowly by running toward her and saying.

Phillip and Amber
Angel, angel, angel, angel.

She turns back, look at them, and she said.

Angel
Oh! You guys are here? What the hell are you both coming from?

Amber
As you can see, Phillip mother was seriously heal, until the operated her, so if we start explaining everything to you now, it will take us a lot of time.

Phillip directly asks her.

Phillip
So who's in the class now?

Angel
Have you forgotten today is still Mrs. Dorothy that will be giving us some lesson?

Amber
Oh!!! I have forgotten.

Amber looks at Phillip and asks him. (So what are we suppose to do now?).

Phillip
Nothing than get our ass into the class and do as nothing happen.

Amber
And if she asks us where we went too, what are we going to say?

Phillip
Same thing we just told angel, and if she want to know the entire story, then, we are going to make her the longest story in the world.

Then, Amber smile and the tree of them went inside the school, when they both were near the door of the class, Phillip said to angel. (You first).

Then, angel went in, before Amber and Phillip decided to go in too, and the teacher look at them and she said.

Teacher
Same people, same fools, so where are you both coming from?

Amber responding while Phillip was crashing his hair as a shame signs

Amber
Sorry ma'am, we were into the hospital.

Teacher laughs at them by saying

Teacher
Hospital? Oh my God, who die this time?

Phillip quietly replies.

Phillip
No one.

Teacher
Phillip, as you want to show me that you're so stupid, then, as from now on, you'll no more be into my class, so; can you go out?

Amber reply back.

195

Amber
But madam.

And the teacher looks at Amber and said.

Teacher
What? You want to follow him too?

Amber follow Phillip back, while Organ and his friends was laughing at them, and angel who listen to them turn back and look at them, then she said to Organ in Chinese.

Angel
Remember Organ, today your laughing, tomorrow, you'll be crying, and no one will be there to help you out (in Chinese). And Organ look at his friend seated near to him, and ask his friend Nick.

Organ
Huh? But what the mother fucking shit, this lady was saying?

Nick
Don't know!

Then, Amber reach behind Phillip by running and she said to Phillip.

Amber
I'm so sorry Phillip.

And Phillip turns his head back, saw her and said.

Phillip
She sends you out too?

Amber
No, but I went out by myself.

Phillip directly put his hand over her waist by saying and smiling.

Phillip
That's why I love you.

Amber
Why?

Phillip
Because you love justice, and you're not racist.

Amber
Oh! Means the time you'll know more about me, you'll love me more.
Phillip still smiling by saying.

Phillip
So, there is still more about you that I don't know yet?

Amber
Oh yes!

Then, finally, both of them reach in front of Amber car, and the seated in front of her car, not inside the car, but in front of it, and Phillip ask her.

Phillip
Do you know; the majority of parents that study with us into the class came into my home yesterday to look for me?

Amber directly became so shock and she reply back.

Amber
What? And why?

Phillip
Just because their children's was having some wrong marks into their exams.

Amber
But was you the person who corrects those papers? *Phillip smile and reply.*

Phillip
No!

Amber
So why coming into your house?

Phillip
Because for them, since the day I put my legs into this school, their children's started becoming stupid.

Amber
But that isn't a good reason for them to accuse you for such things.

Phillip
Your right!

Then, they became silence until 15 seconds, before Amber ump up from her car, and she said to Phillip immediately because she had and idea.

Amber
Guess what?

Phillip
What?

Amber
As you can see, we are going to help those that have the lowest mark in the exam.

Phillip
How?

Amber
By bringing them into a place, and teach them some few physic and languages before we should start the exam to it.

Phillip
What? How it's going to work? Cause as you can see, I don't know anything in physic, what about languages.

Amber look at his glasses who was on his chest strangely and Phillip directly said. (No no no no no, I wouldn't do such things; you want them to know my secrets?).

Amber
No! They wouldn't know anything, cause this time we are going to do it into your house.

Phillip directly stood up from that car and reply.

Phillip
My house? What for?

Amber
Because for me it's the best place to be, and I promise you it will work, trust me Phillip, just trust me only.

Then Phillip agreed, and directly, the bell of the school ring up, and people began to go out, and Phillip and Amber look at them coming out, and he said to Amber.

Phillip
Now that they are coming out, what are we suppose to do?

Amber

Follow me.

And Phillip follow her into the class, when they reach there, they both saw angel who was arranging her bag and trying to go out, then Amber and Phillip reach near her by saying. (Angel) And she turn look at Amber and Amber continue saying. (Please we want you to do something for us, and in the end of the day, I'll give you ten dollars). Angel smile at her by responding.

Angel

Ten dollars? But that's too much for me.

While they both having that discussion, Organ and his tree friends was looking at them by hiding, while Amber was replying back to angel.

Amber

That's why you're my friend and the job I'll ask you to do for me wouldn't be easy.

Then, she brought angel near her, hold her ears and began to tell her the secret slowly, even Phillip didn't listen to her, and directly, Austin was passing by, he saw Organ and his friends hiding behind the door and by trying to listen to Amber conversation, he then ask Organ.

Austin

Hey! What are you guys doing there?

Then, Organ holds him on his neck by bringing him near to him by directly saying Austin.

Organ

Will you shut it down? Watch.

Then Austin look at how Amber was talking into angel ears, and directly ask Organ.

Austin
But what is saying to her?

Organ directly look at him and said.

Organ
You was suppose to know it before us, are you not his friend?

Austin
Nope! We haven't been friends since some days now.

Organ
So if you want know what those planning for, you better becomes Phillip friend again.

Then Austin left them, and directly, Amber finished speaking into angel ears, and they both decided leaving that class, while Organ and his friends saw them coming, they decided to go back by working slowly, until they ran away from that place, so when they both finally reach outside, angel decided to ran towards some students while Phillip ask Amber.

Phillip
But what have you told her?

Amber
Just trust me okay?

Phillip
Okay Seniora!

So when angel was telling to each students something into their ears, they was also running telling to

some others into their own ears too, while nick approach in front of Phillip and Amber and he ask them both.

Nick
Hey guys!

They look at him strangely and he said with a little scared. (Well, as you can see, I seriously want us to become friends, is it possible if I should join your team?).

Phillip
Team?

By looking round and round as if he was searching something. (There isn't any team around here with us, so?).

Nick
I mean, I want to be your friend both, can it be possible?

Amber approach her self in front of him by saying while he was going behind and by trembling.

Amber
Firstly, we aren't a team, but best friends, secondly, to be part of us, you first have to prove to us that your serious.

Nick
Serious how ma'am?

Amber
By telling us the true, everything you know about Organ, I mean any secret you know about him.

Then, he turn back, and started running away from them, while Amber turn back, look at Phillip and began to smile with Phillip, and nick reach near Organ who was trying to go with his friends to play basketball, and Organ saw him coming and directly said.

Organ
What what what? Have you seen a lion?

Nick
More than the lion himself.

Organ
Huh?

Nick
As you can see, I met Amber and Philip, and then when I spoke to them about becoming one of their friends, they ask me to tell them first all your secrets.

Organ laugh at the word because it was so funny and his friends was looking at him as if he was already going mad, before he stop laughing, got angry and ask nick.

Organ
Don't tell me you haven't told them my secrets and my plans?

Nick
No no no no, I haven't done that.

Organ
Okay, you know what, I suggest you, to go and tell them everything about me.

Immediately, his friends look at him strangely and shouted at the same time by saying.

Organ friends

What?

Organ

Yep! Just go, speak to them, and if they ask you any question about me, just tell them the truth, but understand that the more you'll speak, the more you also have to lie to others secret, just for them to trust you.

And Nick agreed, then went back to meet them, while Organ and his two other friends was going to play basketball by beating the ball on the floor, so when nick reach near Amber who was speaking with Phillip, he then said to them both.

Nick

Guys, I finally came to tell you the truth.

Phillip

About what?

Nick

About Organ secret.

Then, the look at him strangely, and Amber said to him.

Amber

But what are you waiting for, go on, speak.

Nick started telling them everything about Organ secret and by remembering the past as a vision.

Nick

Okay, as you can see, the day Mr. Ryan geography book got missing, it was Organ who took it and hide it inside Phillip bag fro him to be accused and send

out from the school; the other day, when the FBI caught you both, it was also Organ who send them over your house to come and pick you up and put all the students into jail, and Organ has a little sister name Sasha, and that right now she's sick of cancer, and that Organ don't want people to know about that, Organ other secret is..

Angel reach near them, and Amber look at her, and she ask angel.

Amber
Have the news has been send to everyone already?

Angel
Yes.

Nick asks them.

Nick
What type of news are you guys talking about?

Amber looks at him and said.

Amber
First of all, those secret you just told us, wasn't the type of secret we was wanted to know, cause for me, everything bad happening to Phillip, wasn't coming for nothing, so if you have anything good to say that we doesn't know about Organ, call us.

Then, she went inside her car, while Phillip went too, and angel looks at them strangely, before Amber said to angel. (But, why standing there?). Then, angel went and enters inside Amber car while nick was asking them.

Nick
But where are you guys going?

Amber
If you have some difficulties in physic or languages,
just come over Phillip house at 2pm.

*Then, started riving the car by going, and nick
shouted to them.*

Nick
But where does Phillip leave?

*And Phillip shouted over by giving him the number of
his home address, then that is how times was passing
very fast, and those students; even nick, came into
Phillip home, and Amber, Phillip, angel, put some
big books of languages, and physics on the table,
and Phillip wear up his glasses, and they began
to study, and study, until the fall on the floor,
some fall on table and slept, and the morning came,
when nick stood up, he saw Phillip glasses on the
table, when he pick it by trying to put it on his
eyes, directly, Phillip open one of his eyes, and
took back his glasses, hide it inside his t-shirt,
and fallback and slept, then days continue running,
and the time of the last exams, Phillip and all
the students reply to those question very well, and
days continue going; Phillip was seated besides his
mother in the hospital, with his family, and Amber,
laughing together, and telling funny story's.*

*Day's continue, until the day of the finally result
for the students to be graduating, that day, school
was already prepare, and it was already the night
like 6:30pm. And many students was coming into
the school with big, big cars, and with their
parents too, even Phillip came there, but with
out his parents, and that was the day, Mrs. Jane
was coming out from the hospital helping by her
husband. So when Phillip reach inside, he began*

to look at beautiful places, and he was so happy,
by looking at how some students was holding each
others by dancing, so he look at a chair, went there
and seated on it, so when he was sitting alone, a
beautiful lady began to come inside the school and
forward him, very well dress up, and looking good,
until she approached her self near him by smiling.
And it was Amber, and also more gorgeous than ever.
Phillip stopped breathing for a few seconds before
Amber pulled him out of his trance.

Amber
Hey, what's up?

Phillip
Nothing, it's just that, you look so beautiful. Can
I have a dance with? You?

Amber
Why not?

They begin dancing, they have a great time, laughing,
shouting until they were out of breath. While
dancing, Chris who was standing near Organ look at
Amber and Phillip, and finally notice that Phillip
was having his glasses on his t-shirt, and he ask
to Organ.

Chris
Organ, have not notice that, Phillip has never left
his glasses into his house?

Organ
I know that, but have you forgotten that, with out
those glasses he can't see well?

Chris
Point of correction, read well.

Then well Phillip was still dancing with Amber, directly, his glasses felt down, and he didn't knew, then, the younger sister of Organ who has cancer with her hair shaving and who was there sited on her sickness chair, started working on her knees toward those glasses until she peak it up, and left that place by going back on her chair, and directly, her mother reach behind her and said to her.

Mother
Baby, I was looking for you everywhere.

Then hold that chair where her daughter was, and began to push it toward the other side of the hall of the school, so, by going over there, that little girl show up those glasses to her mother by saying.

Organ sister
Mom, look what I have over here?

Then, her mother look at it, took it from her and she said.

Mother
Oh my God, you took it from where?

While she was showing where she pick up the glasses, that same moment, Organ reach there, saw the glasses and asks to his sister.

Organ
Hey! Where exactly have you seen this?

Then the mother replies back.

Mother
She just told me, she peak it from that place people are just dancing.

Then Organ said to the by taking the glasses from his sister.

Organ
As you can see, this glass is from Harry potter, so you both don't have to touch it this way.

And her sister was so happy and she ask Organ.

Sister
Really? Means I have touched harry potter glasses? Oh my God, give it to me again, please.

And Organ replies back.

Organ
No no no no….

By going with it to a place his friends, Phillip and some others people wouldn't see him, then, while Phillip and Amber stop dancing, and Amber said to Phillip.

Amber
Oh my God, I'm really tired, let's rest first.

Then, they left that place where they both was dancing, then the went and seated some where, and angel came inside that hall place, then, saw Phillip and Amber, and started working toward them; when she reach near them, she greeted them, and ask them.

Angel
It's like you guys are already tired before the time we will inform this night, who's the queen and king of the year?

Amber
Oh yeah! Specially me.

Then, directly, Phillip looks to a different place, and he finally saw Mr. Yuan Chang coming toward them, and became so scared and asks.

Phillip
But what does this man came here to do?

Then, Amber and angel turn and look at Mr. Yuan chang and angel reply back to Phillip.

Angel
That person you just call a man, it's my dad.

Phillip directly stood up by saying.

Phillip
What?

And Amber started follow him back and by saying to Phillip.

Amber
But wait for me Phillip, wait for me.

Then, they both reach on one place and began to smile, while the principal came to announce the result of everyone, when the principal was out, he took up the paper, firstly, he spoke to all the students how the year was so difficult, etc.. then, gave to many people their own graduation, even to Phillip friends, but the time of mentioning the king and the queen of the year, many students was so surprise while Amber who found a book on a table having a lot of questions, so she look at Phillip who say to her.

Phillip
But what?

And she shows the book to Phillip and said.

Amber
What if you should use those glasses for the last time, and ask me some questions from this book, for me to try on and answer it all?

Phillip smile at her and said.

Phillip
Hmmm…. That's a good idea.

In all his excitement, Phillip wanted to put on the glasses to for some experiment with Amber and he couldn't find it. Phillip and Amber kept looking for it until he remembered that he dropped it last at the restroom and the only person that came there was Organ. So he suspects' Organ must have taken it. So Phillip and Amber went round school looking for Organ. Meanwhile, Organ that was in possession with it puts them on and he was just surprise that the glass was showing people normally than showing people on a medical way.

Organ
What is this? (Ask it from his brain).

But when he wanted to remove it from his eyes, the glasses started writing himself, and Organ look at it strangely, and the glasses was saying.

Glass
Welcome to the base system of Chang technologies. What is the user's name?

Organ
Umm.. Phillip…. Hmmm…… Johnson.

Glass

Incorrect username, try again.

Organ

Umm..Phillip Johnson?

Glass

Incorrect username, try again.

Organ removes the glasses, and said to him self.

Organ

Oh!!! This is how Phillip was cheating at us all this while.

Then, he saw Austin passing on his way and he ran toward Austin by bringing the glasses to Austin who is good with technology. At that same moment he was bringing the glasses to Austin, the principal look at the result strangely, and before waited for six second before decided to spell the name and the queen of the year, and those people was Phillip and Amber who listed their name while the was looking for Organ, then, angel saw them, and she was so excited, and she shout by calling them to come and take it, while Phillip went first until he got his own card, then they call Amber, who went after, took her own, and that's how a lot of people was happy for them, and the ask they both to have a dance, and they went and began to dance, by waiting for Organ to show up, that same moment, Organ finally reach near Austin by saying.

Organ

Hey Austin, can you look this thing up and tell me what it is?

Austin

Let me have a look.

After looking at it, he saw some question asking him his user name, and then said to Organ. (I think I have to check this thing with my computer). Then connects it to his laptop, type some code on his laptop until the glasses came on, and he started make some research in it by working on some programs, then look at some questions they have been asking them in school and said to Organ.

Austin
It looks like some kind of smart glass. Its recent activity shows some. Answers of math, physics, and languages questions. Hey! Wait a minute, these are the exact same Questions that came in our exam!

Organ understood everything and took the glasses from him. Meanwhile, there was a little get together party and everyone was present. He ran towards The hall, where everyone was; while Austin ask him back. (But are these not Phillip glasses?). Directly Amber and Phillip saw him coming With the glasses, Amber tried to run after him and take them from him but Phillip, guilty, stopped her. Organ takes a microphone and announces

Organ
Everyone! Can everyone please lend me your ears for a few minutes? Thank you. Now, I've got something really important to tell you. Recently, Our friend Phillip, has become the highest scorer in the exams right? I bet We all want to become like him right? Well, the good news is that it isn't very difficult! All you've got to do is get this Scientist Eye Glass and your wisdom will exceed all known limits, because this thing right here in my hand knows everything. So there you go, you can easily be the next Bill Gates or the next Oprah Winfrey. Austin can you tell us more about it? Austin reply back by

approaching toward the public, while Phillip was doing some sign to Austin, and was ashamed already.

Austin
Thanks Organ.

Austin hooks up his laptop to a large projector screen and explains the working of the device along with how Phillip used it to his advantage, while the Mr. Yuan directly came back in, and he saw how the was using those glasses, and he didn't say anything, but look at how people was making Phillip to be ashamed. And the students skeptical at first were now of the opinion that Phillip was a terrible cheater and what he had done wasn't worthy of forgiveness. Phillip's physics teacher astounded came to him and asked him

Teacher
I know that what you've done is horrible and you need to be punished. But we all are willing to forgive you if you answer all the questions that I'm going to ask you correctly, alright?

Phillip
Okay ma'am.

Then, the teacher looks at the public and says to them.

Teacher
Listen every one, we all know Phillip did the biggest mistake in school by using this classes, but...

Organ shouted inside the hall by saying.

Organ
By making us to look like fools?

And the teacher continue saying.

Teacher
He hasn't make us to look like fools, he make us to
understand that, none of us in this world is stupid,
cause we were all created by one hand, and one God,
even that he has use this glasses to do such stupid
things into the exam.

Organ asks.

Organ
Okay Mrs. Parker, as you always supported him; can
you both show us and example?

The principal who was listen to them said.

Principal
Not only and example, cause this guy has to be send
into jail, cause this thing he just did is against
the America law.

Teacher
No one we go to jail, he did what was good to be
having a great note in school, and secondly, but I'm
going to show to all of you and example.

*Then, The teacher turn, look at him and asked him
several questions, the first question the ask him,
Phillip began to think until he went into the past
through his vision, still the day he started using the
glasses in school, until the day he was learning his
classmate to; through that, all the answer's Phillip
was giving to his friends, and posting on his exam
paper, he began to remember it all, and while thinking
so, Amber was so nervous to see him failed it, and all
they students was looking at him strangely, before that
is how when he came back into his senses and into the*

present, he answer the first question, and the teacher took tree seconds before telling to every one that it was the right answer, and that is also how; he was able to answer them all without any help. His intelligence won his classmates over and they began Cheering for him even Amber and Mr. Yuan was only smiling.

The teacher runs out of questions. Phillip is surprised, while Organ was so jealous and became so shame full by leaving the hall and going back to his house, while Phillip parents began to approached them self toward Phillip by smiling toward him. So, when he saw his parents coming towards him he approached himself from them, while the students was congratulating him by touching him on his shoulder, and his parents was smiling by still coming near him while Organ was leaving that hall with shame.

Phillip
Hey mom and dad, when did you both came?

And he carried his sister Jessica by kissing her on her cheek when his mother was replying back to him.

Jane
When you were answering all those questions perfectly son. You made us proud Phillip, and cause of that, we finally find out that we haven't brought into this world a foolish son. Even that we haven't see you Graduating, Oops, and Sorry!

Phillip
Its okay mom.

Jane
As you wish son

Then the Chinese directly came toward Phillip, and he ask to Phillip.

Yuan
Can we talk privately?

And Phillip replies back to him by looking at his mother strangely away from them to leave him alone with Mr. Yuan.

Phillip
Why not?

Yuan
You know, I have always knew that this glasses will be helping you one day, but for me it wasn't you to use it in school, especially in your exams.

Phillip
I am so sorry sir.

Yuan
You don't have to be sorry, cause I am the one who did all that, and for real, I think it's better for you to broke those glasses, cause the use of it wouldn't help you anymore and any where you'll be going too.

And Phillip turns up his face by showing it on a sad way and he said.

Phillip
I know, but I can't.

Then look at those glasses by still making a sad face and Yuan said to him.

Yuan
I know you really love those glasses, and enjoy using it when you were facing difficulties in school, but the best thing for you to do is to break it and continue a normal life like others.

And Phillip directly replies back with a sad face.

Phillip
But I am normal like others.

And Yuan quietly said to him by looking at him with an angry face.

Yuan
You're not normal, until you will break it up to be normal like others, so broke it down Phillip, broke it now.

And Phillip immediately replies.

Phillip
Okay, I will.

Then, look at all the students who were smiling and even Amber that was having a conversation with angel, and he then shouted by saying out loud.

Phillip
Well, everyone look at me.

All students approached themselves and look at Phillip strangely, while he continues... (Well, as you can see, I did a lot of mistakes into the past, and I don't want the same mistake to be repeating into the present and into the future, so I think the better thing for me to do, is to broke these glasses and stop cheating to school and to others by using it). He's mother said...

Jane
Oh!!!! He cheated in school? This guy has to listen to me.

While she was wanted to go and beat Phillip up, her husband August hold her back, then said.

August
Wait first.

And Jane quietly reply back to August.

Jane
Why?

At that same moment Jane ask 'Why?', Phillip directly try to broke it down, While Amber shouted by showing her hands to him on a sign of no, and she said.

Amber
No! Don't do that.

Phillip who hasn't broke it down look at her strangely and asks her.

Phillip:
What? Why should I not do that?

That same moment, Jane said too.

Jane
Good question Phillip.

Amber
Have you forgotten that these glasses has help you in many different way's, look, through this glasses, you use it to teach and make all the students to understand the different between capital A to capital B.

Phillip
But what are you talking about?

That same moment Phillip ask Amber; Ms Jane turn look at her husband and ask him that same question Phillip just ask to Amber.

Jane
Yea! What is she talking about?

And August reply back

August
Just watch and you'll know. While that same moment when August said that to her wife, Amber was continue replying to Phillip's question.

Amber
Through these glasses, you help your mother to be having the good operation into the hospital. Directly, Jane approached her self toward Amber by asking her.

Jane
Are you serious? Then why did you not tell me that this glass is also building dollars?

Amber looks at her and replies.

Amber
It isn't building dollars, but it through it that Phillip uses it to answer some of the greatest test questions into where we went too, to find the $80 for your operation, and what happen if he broke the glasses? What will happen next if the glasses will be in some others used?

Directly, August who was still carried his daughter on his shoulder ask him self this question, with a silence voice.

August
Which part of this story did I miss?

At that same time, when August was asking that question to himself, Phillip who shut Amber who was

220

*trying to continue her word on "used?..."; Phillip
directly ask her.*

Phillip
Wait a minute. Do not tell me that I will be a
cheater in my whole life?

August began to approached Phillip.

August
No, Phillip, you wouldn't be a cheater any longer,
but you have to keep the glasses into a nice place
where no one will see it any more, cause these
glasses has also bring you some victory, and has
also help you in many other ways, like, helping
you to find the $80 the doctor was asking for your
mother operation.

Austin said to Phillip

Austin
Phillip, he's right, listen to us, this glasses
hasn't only safe you in school, but also safe one
life, who knows what will happen if Organ wasn't
exposing your secret just like that, maybe, it could
be saving many life tomorrow, so we suggest you to
keep it.

Then Phillip mother said to him.

Jane
They are all right Phillip, the glasses has Really
help you safe my Life, and not only my life, even
your friends in school, so if you broke this glasses,
maybe you'll regret it one day, cause everything
that happen to us in life has a reason.

*Then Phillip looks at all the students who were
saying to him.*

Students
Do not breake it Phillip, do not.

Then Phillip look at Mr. Yuan strangely who himself finally said to Phillip.

Yuan
If what they have just said is true, I think you have to listen to your heart, what your heart is telling you, and you'll finally make a good decision.

And Phillip looks at his friends, Family, and they rest of the students before finally said to them.

Phillip
You all are right, and as you can see, I will…….

Every one was scared thinking he will be broking it, while he was looking at them strangely on a way will deceive them, before he finally said after 4 seconds. (Not broke it). Then everyone began to jump and cheers him up, and was very happy for him, and he began to smile too while Austin said to the public.

Austin
But what are we still dong here, let us go and dance. Wou Hooo….

Then, they began to follow Austin to the dance hall, and started dancing while the Dj send a put on a song very louder for them to dance, while Phillip parents came to him, with Jessica, and Phillip started smiling over to them, and his mother who finally reach in front of him, Slap him on his cheek, while Amber quietly said to herself (Oops!) at that same moment, Mrs. Jane said to her son.

Jane
Oops, sorry I did that, but for real, you seriously
put me into my nerves; so how are you son?
Phillip began to smile and said to his mother.

Phillip
I'm okay mother.

*Then carry his sister on his shoulder, while his
mother turn and look Amber and said to her.*

Jane
I am sure one day you'll be my son wife.

Amber smile back to Jane and said.

Amber
Come on Mrs. Jonson.

*They both smile out loud by pushing themselves away
while a man from the CIA approached them and showed
his CIA card.*

CIA man
Sorry to disturb, I am Mr. Hamilton from the CIA.

*Mrs. Jane replies back to him nervously and by
quietly saying to him.*

Jane
No no no no no, you wouldn't come into this place to
arrest my son for something he hasn't done, what's
the hell is going on with your ass? Huh!

*And, the man show his hand by saying to Mrs. Jane
while she was trying to beat him up...*

CIA man
No no no, I didn't come here to arrest your son, I
came here to make a proposition for him.

And directly, Mrs. Jane look at him by stop be nervous and ask him directly at the same time August, Amber and Phillip said the same thing to the man.

Phillip, Amber, August, Jane
A Proposition?

And the man look at them, smile and said to them.

CIA man
Yes, a proposition.

August
What type of proposition is that?

CIA man
It's a contract.

Jane
A contract?

Mr. Yuan reach in front of them and look at them while The CIA man was answering Jane to them.

CIA man
As I earlier, I am working for the CIA. I want to sign a contract with this young man. I mean with us, ha ha. I listened to all the conversation that was going on in this hall, about that eye glasses he's holding. I have decided to draw up, I mean have a contract with him, for him to work with us the CIA. So that this glasses can be of good use for the CIA, for the protection of the American Citizen. What doyou think about that?

Phillip said to him.

Phillip
Beside, I'm not the one who created the glasses.

CIA Man
Then who?

Yuan look at him and said.

Yuan
Me, but if you want to sign anything like a contract, it has to with be Phillip, not with me; I am just here to assist him.

Then, he touches Phillip on his shoulder by saying to him Phillip. (Good luck). And began to go while Phillip point his hand by calling him back and saying.

Phillip
But wait!

Jane ask the CIA Man.

Jane
But what type of proof do you have as a worker for the CIA? Huh?

Directly, Austin approached toward them by saying to them.

Austin
Hey! He's my dad.

And Phillip and Amber turn immediately look and Amber by saying at the same time quietly.

Phillip, Amber
Your dad?

Austin reaches beside them by saying.

Austin
Yep! He's my dad, and trust me guy's, he's saying the true, he work for the CIA.

Directly, Phillip and Amber look at the man and began to say.

Phillip, Amber

Hmm……….

And directly, a literature name Sasha Newton began to work fast by coming toward them by saying.

Sasha Newton
Wait! Before saying anything, I have something important to say too.

And she began to greed them on their hands and by continue saying.

(as you can see, my name is Sasha Newton, I am a literature working for the SPB, means 'Students provider books', we are they one bringing students story's into books, students that their story's was very impressive into their high school, for their story's to teach a lot of others students around the world to become great, patient and prudent).

Then, Jane asks her.

Jane
So you mean, you want to write a book for my son?

Sasha Newton
Yes ma'am, that's what I want to do.

Directly, Phillip and Amber became so happy, and Amber said to them.

Amber
Oh my God, I am sure this book will be very nice, and can make Phillip to be famous, ha ha ha

August
So what should we do? Sign a contract with you too?

Sasha Newton
Yes, that's what we will do.

Jane
Hmmm, amazing, so what's will be the title of that book?

Sasha Newton
don't know yet, we will find out when we will start writing it

Amber
You know what? I think the title will be Phillip in Los Angeles? Or….Hm…. I see. Then, look at them all, even that CIA man and finally said.

(Phillip and the eye glass will be the title of it, yeah!). Phillip smile, while all the rest was saying.

Jane, August, Austin, Sasha, Hamilton
Phillip and the eye glass?

Amber
Uh huh, Phillip and the eye glass.

August
So when are we going to sign the contract?

CIA Man
Hmmm, I think tomorrow.

Sasha Newton
Yes, tomorrow and the same place.

Then August began to greed them on a sign he has agreed by saying.

August
Okay! Tomorrow, same place, but where exactly it is.

CIA Man
Into my office.

August
Means, we all have to come over your office?

CIA Man
Yes, even you Mrs. Sasha.

Sasha Newton
Okay, as you wish!

Amber hold Phillip hand, and she said to Phillip.

Amber
Follow me.

Quietly, Phillip gave Jessica to his mother by kissing her on her cheek and said to Jessica.

Phillip
I am coming little sister.

Then, follow Amber by running behind her, and when they both reach where others was dancing, Amber look at angel who was sitting with her boy friend dancing, and Amber smile at her, and she smile at Amber too, and then, Amber hold Phillip hand, while the music was still going on, Amber said to Phillip

Amber
Let us show them what we have Learn.

Phillip
Okay!

Then, she began to dance, and Phillip too, and all the students who was dancing began to give them the way by making a big space and a big circle, and cheering them up, and laughing, and Phillip also dance, and when August, Austin, Sasha, Jane, Hamilton saw them dancing, they began to approached themselves toward that place to watch them dancing, and that's how they both were dancing and dancing, and the students, even they teachers were also cheering them all. So after that, the next day came, where Phillip, Jane, Amber, Austin, August, were all standing up in front of Hamilton, and the general of the CIA signing the contract Hamilton was talking about, and they was cheering all, and smiling, and Phillip took the glasses he was holding and put it inside a security bag for the CIA and he close it, and they all continue cheering for him.

Then, Mrs. Sasha brought her own contract, and Phillip sign it too, and they continue cheering Philip, and then, the they all cheers up the cup of juice, and began to drink, after some that, years began to go, like one year later, a yellow big book was selling into high schools in CALIFORNIA, NEW YORK CITY, VEGA, ATLANTA, PARIS, GERMANY, GREAT BRITAIN, AFRICA, RUSSIA, CHAINA, COREA, AND THAT IS HOW PHILLIP STORY WAS KNOW AROUND THAT WORLD.

END.

FADE OUT

Printed in the United States
by Baker & Taylor Publisher Services